Making Art Together

Making Art Together

How Collaborative Art-Making Can Transform Kids, Classrooms, and Communities

Mark Cooper and Lisa Sjostrom

❋ Beacon Press, Boston

Beacon Press
25 Beacon Street
Boston, Massachusetts 02108-2892
www.beacon.org

Beacon Press books
are published under the auspices of
the Unitarian Universalist Association of Congregations.

09 08 07 06 8 7 6 5 4 3 2 1

This book is printed on acid-free paper that meets the uncoated paper ANSI/NISO
specifications for permanence as revised in 1992.

All photographs © 2006 by Mark Cooper

Text design and composition by Dean Bornstein

Library of Congress Cataloging-in-Publication Data

Cooper, Mark.
 Making art together : how collaborative art-making can transform kids, classrooms, and
communities / Mark Cooper and Lisa Sjostrom.
 p. cm.
 ISBN 0-8070-6618-4 (hardcover : alk. paper) 1. Art—Study and teaching (Elementary)
2. Group work in art. 3. Community art projects. I. Sjostrom, Lisa. II. Title.

N350.C68 2006
372.5—dc22 2006008523

Contents

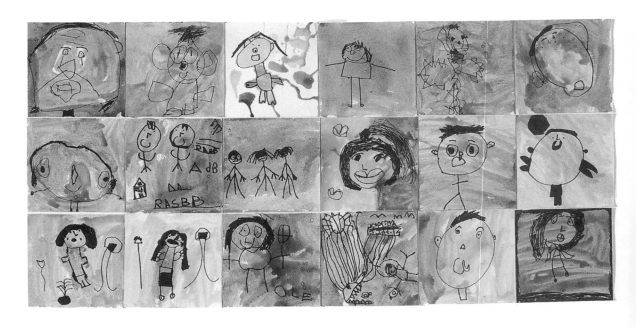

Self-portraits by kindergartners arranged in a grid. Beautiful and simple.

Chapter One

Collaborative Art: Making Magic

A Simple Start

Take a large sheet of paper and grid it into squares. Ask each of your students to decorate one square however he or she likes—with a solid color, for example, or a drawing of a face, or a pattern of circles, squiggles, or lightning bolts. This is a bona fide collaborative art project. Simple. Basic. No doubt you've done something similar many times before.

To up the ante just a little, have your students first paint a light shade in each section and then draw on top in a darker, contrasting color. Better yet, after students paint their squares, have each of them shift one position—right or left, or up or down—and draw or paint in that square.

Glue the colorful grid to a larger piece of paper, a do-it-yourself frame, and ask students to sign their names or trace their hands in the border.

Now, imagine blowing this up to billboard size. Repeat the process, only this time have each student decorate a large, 5 ft. x 4½ ft. paper panel. Contact a local billboard company and recruit them to display the resulting billboard for free right in the neighborhood.

This is an example of the way I've worked with kids and teachers for more than twenty years. We start small, and then, step by attainable step, layer by colorful layer, build complexity into a project. Children's art typically calls to mind small creations: individual drawings, clay figurines, masks, puppets. In contrast, I work with kids to create large-scale masterworks, often considered the exclusive province of adult master artists: 50 ft. x 30 ft. mixed-media sculptures, 550-tile bronze installations, and world maps big enough to cover the side of a truck.

During the collaborative process, magic happens. Who knew that regular kids, not just select stars, could be taught to work and *think* like real artists? Who would guess that kids could produce such sophisticated and meaningful pieces of art? Who imagined such ambitious projects could be pulled off within the constraints,

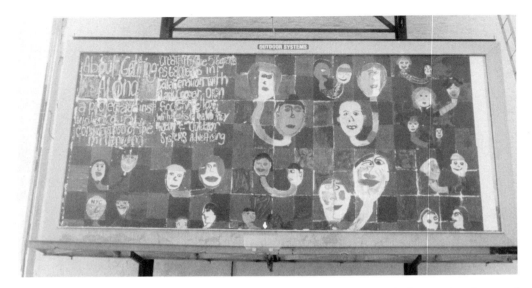

Billboard made collaboratively by kids from seven schools in New York City on the theme of Getting Along.

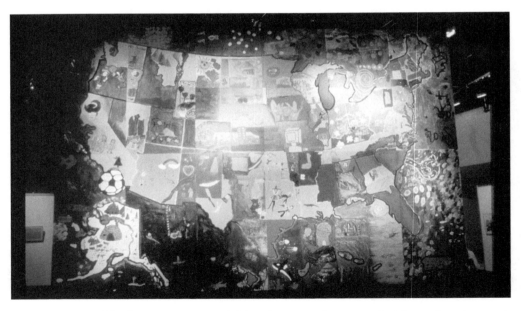

U.S. map painted by forty-nine young children between the ages of eight and twelve, each representing his or her home state.

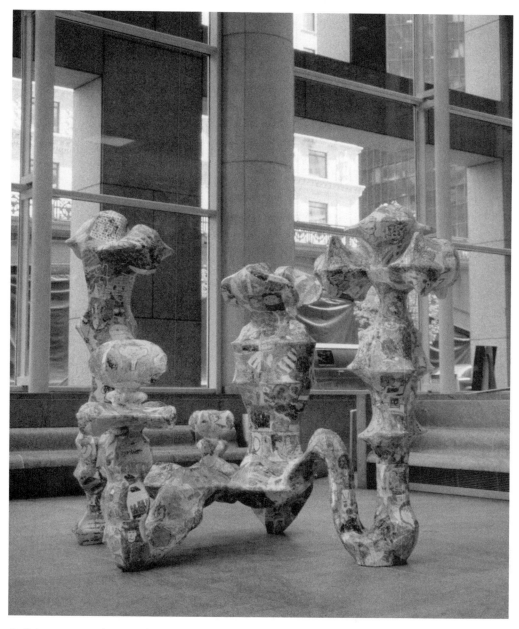

Collaborative sculpture, displayed in the Whitney Museum at Phillip Morris, part of a larger project by hundreds of New York schoolchildren.

budgetary and otherwise, of local schools? As important, who could have predicted the unifying effect the collaborative process itself would have not only on kids but on classrooms and surrounding communities?

Educators understand the importance of helping every child to have a voice, to feel part of and responsible for community, and to be involved in making decisions for the common good. Kids are not only better citizens but also higher-achieving students when they understand and value the differences that make up the *pluribus* while they also experience being part of the *unum*. The challenge is to figure out how to create this kind of democratic community with kids.

Collaborative art-making is a profound way to do this. I see it every time. Kids are overwhelmingly enthusiastic, and they're involved in the whole range of artistic activity, from conceptualization to execution. Students who normally sit on the sidelines find themselves on equal footing with their peers. Everybody debates and votes about what to create: Shall we make a giant puzzle piece, a hanging mobile, or a mural? And everybody makes an artistic mark—even if it's just painting a square orange. In the process, the participants develop relational skills and emotional intelligence, two attributes that are finally being recognized as crucial to lifelong success.

What never ceases to amaze me is the pride and sense of ownership every student expresses at the end: "*I* made this. Isn't this great?" Don't underestimate the force of this kind of pride. It's a huge self-affirming lesson for a child to experience a job well done, especially a job well done with others. *Together we can create what we could never create alone:* This idea lies at the heart of collaborative art-making. What an essential lesson! It can't be taught too often.

A New Spin on an Old Idea

Human beings yearn to make marks and embellish the world. And throughout time we have collaborated. The well-known cave paintings in Altimira, Spain, and Lascaux, France, while not collaborations in a strict sense, were likely added to over time by different artists fifteen thousand years ago. Countless artisans worked over many decades to build the great Gothic cathedrals in Europe and the Buddhist temples in Asia. Most Renaissance masters had teams of artists working alongside of them: Michelangelo painted the Sistine Chapel with a crew of painters; Picasso teamed up with potters; Andy Warhol had a staff of assistants. These days, there

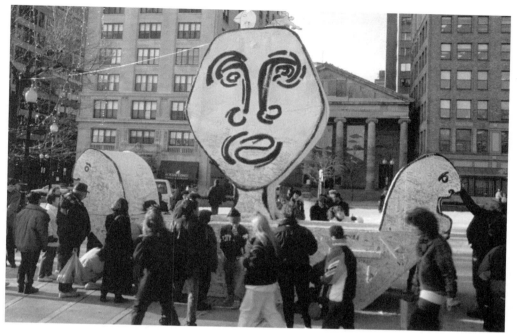

Outdoor public sculpture for First Night, Boston, with New Year's wishes inscribed by thousands of people.

are Christo and Jeanne-Claude, who wrap buildings and surround islands with the help of hundreds of people in hundreds of communities; and there's Claes Oldenberg, who collaborates with architects to create his giant lollipops, clothespins, and other soft sculptures of everyday objects.

While there's nothing new about collaborative art-making, what *is* new is bringing this approach into every classroom in every school of the country. It's one thing for a famous artist team to collaborate or for the Dadaists to play a collaborative game; it's another thing to design a pedagogy that's central to learning in all disciplines, not just the art room.

First Night, Boston

When I arrived at art school in 1978, there was no seminar offered in Collaborative Art-Making. Even today, the primary focus of most art educators continues to be on the unique object and the singular vision of the artistic genius.

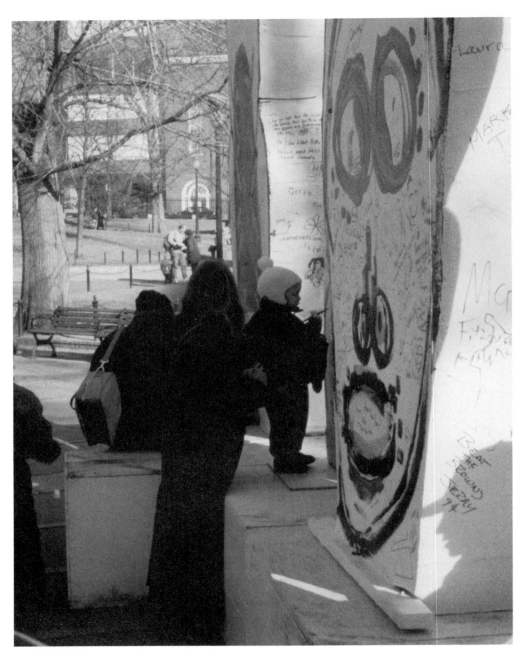

First Night, Boston.

This mindset radically changed for me in 1988. That's the year the organizers of First Night in Boston asked me to create a large sculpture for the citywide New Year's Eve celebration of the arts. I was given free rein to design whatever I wanted, with one caveat: The public, both children and adults, must be able to interact with the sculpture in some way.

I decided to base the sculpture on the myth of Janus, the Roman god of gates and doorways. Doors and gates were sacred to Janus, as were all beginnings, which the Romans believed were crucial to the success of any undertaking. Janus's blessing was therefore requested at the start of every day, month, and year; the first month of the year was named for him. In art, Janus has been represented with two faces peering in opposite directions—one to the past and one to the future.

I built an 18 ft. x 24 ft. x 12 ft. sculpture in the form of two masks, one facing left and one right. It was built of wood and canvas, which I primed white, and was light and moveable, so that I could disassemble it and load it onto a truck and then reassemble it on the Boston Common. I crossed my fingers that people would find the sculpture visually interesting enough to relate to it.

I hired a crew to assist with the entire process from setup to takedown. We were outside for eighteen hours straight, standing on the sculpture and handing out bags of colorful markers to the oceans of people who surrounded it from 9 A.M. till midnight. In dozens of languages, the crowd wrote New Year's resolutions. They made vows to mend broken relationships. They resolved to lose weight. They proposed marriage. They pledged to be better to their children. They committed to return to Croatia. By the end of the night, the surface of the sculpture was so crammed with text and imagery, it made Jackson Pollock look like a minimalist.

It happened that, at the same time, my own artwork was being exhibited at the Institute of Contemporary Art (ICA), located about ten blocks from the Common. Major journals had given me rave reviews, and the *Boston Globe* referred to my work as ingenious. The ICA exhibition drew an audience of 40,000, a rollicking success by museum standards. Yet . . . yet . . . more than *1.5 million* people had interacted with the Janus sculpture! That's nearly forty times the number who'd visited the ICA. Each person had had the chance to make a very public statement in a very public communal ritual. And everyone, millions of people, shared a sense of ownership in the amazing piece of art that resulted.

It was some time during that First Night that I had this epiphany, that I really *got* the power of collaborative ritual and art. In the past I'd scoffed at this venue and dismissed it as diluted low art, in much the same way that children's art is often dismissed. I suddenly realized that a piece of collaborative art made by nonartists could be as remarkable an object as anything I'd ever exhibited. More remarkable, in fact, because in bringing together multiple collaborating voices and techniques, there's no limit on the quality of art produced. Looking at that Janus sculpture was like reading thousands—no, make that millions—of books at once. There's no way that I or any other single person could have produced the power and humanity of all of those voices.

First Night in Boston invited me back for ten years running. The sculptures continued to be wildly successful, seen by millions of people and read about by even more, many of whom have called me up and invited me to run collaborative projects all over the world. While I enjoy making art in every venue—libraries, museums, office parks, playgrounds—it's become clear to me that schools are the best settings for these collaborative projects. Schools are ubiquitous, the heart and soul of every community, rich or poor. And attendance is compulsory; you never have to worry whether or not your artists will show up. Moreover, a complex collaborative project—even one involving five hundred or more kids in the creation of something *really* big, like a twenty-foot-high sculpture or a life-size billboard—can be broken down into simple, achievable steps and duplicated by any teacher anywhere.

Basic Principles

My approach is built on five basic organizing principles that apply in every situation, whether you're working with children, teens, or adults.

PRINCIPLE 1: The teacher serves as master artist.
PRINCIPLE 2: Use a framework to maximize the likelihood of success.
PRINCIPLE 3: Work collaboratively throughout.
PRINCIPLE 4: Draw on the perspectives and techniques of contemporary art.
PRINCIPLE 5: Tie the artwork to the larger world.

I devote the next five chapters to each of these principles. They overlap and interconnect, but each theme has its own integrity. They are all essential to the unlocking the full power of collaborative art with kids.

A Kindergarten Classroom

In 1999, I got a call from David Harris, a kindergarten teacher at P.S. 196, located on Twelfth Street between Avenues B and C in New York City. The theme for the year was Families, and David wanted his four- and five-year-olds to not only talk about families, but also to see and experience the concepts they were learning about. As he told me during that first conversation, "Bringing a family's favorite dish to school is great, and delicious, but it doesn't tell you that much about a family. I want kids to get a fuller picture. I want them to see the kitchen it's made in and hear the conversation going on during dinner."

David came up with the idea to have his young students visit one another's homes. He called each family, scheduled a good time to visit, got permission slips signed, and trooped out eighteen times with his eighteen kids to eighteen different apartments all over the Lower East Side. Following each visit, David wanted the class to document and make sense of what they'd learned. They'd talk about their impressions, but given kindergartners' limited attention span, these discussions would invariably be short and forgotten by snack time. Writing was out of the question, since the kids didn't know how to write yet.

David and I put our heads together and dreamed up a simple little-kid-friendly art project that met his basic stipulations: (1) the children would make artwork that represented what they learned on each visit; (2) their different perspectives on each family would come together in one place; and (3) the kids would have a tangible artifact to return to again and again to remember each trip.

The project followed essentially the same principles given earlier. David started with a 4 ft. x 3 ft. piece of canvas. After each visit, kids painted pictures on small pieces of paper illustrating what they'd just seen: moms and dads, pet lizards, TV sets, skateboards, bubblegum stuck under a table. The students and David then glued these paintings to the big canvas, leaving room around the border for written descriptions of each picture. David transcribed the children's words in English and Spanish; he even had a parent come in to write in Arabic. "All of the children's observations were included," he recounts, "ranging from 'Andre sleeps with a

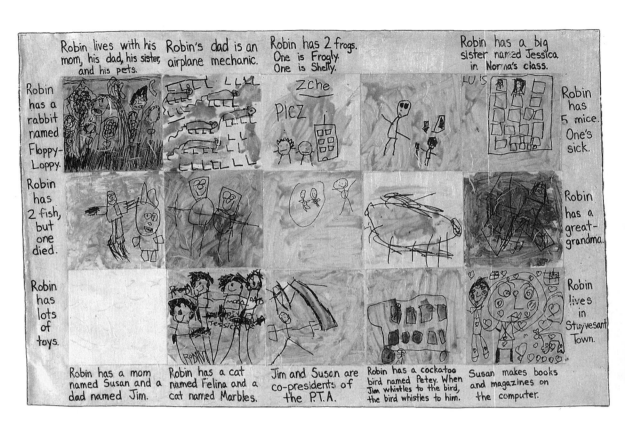

Robin lives with his mom, his dad, his sister, and his pets.

Robin's dad is an airplane mechanic.

Robin has 2 frogs. One is Frogly. One is Shelly.

Robin has a big sister named Jessica in Norma's class.

Robin has a rabbit named Floppy-Loppy.

Robin has 5 mice. One's sick.

Robin has 2 fish, but one died.

Robin has a great-grandma.

Robin has lots of toys.

Robin lives in Stuyvesant Town.

Robin has a mom named Susan and a dad named Jim.

Robin has a cat named Felina and a cat named Marbles.

Jim and Susan are co-presidents of the P.T.A.

Robin has a cockatoo bird named Petey. When Jim whistles to the bird, the bird whistles to him.

Susan makes books and magazines on the computer.

Collaborative collages as family portraits from the kindergarten class of David Harris. The entire class worked on panels for each child's family. Kids made the pictures, composed the text, and designed the whole.

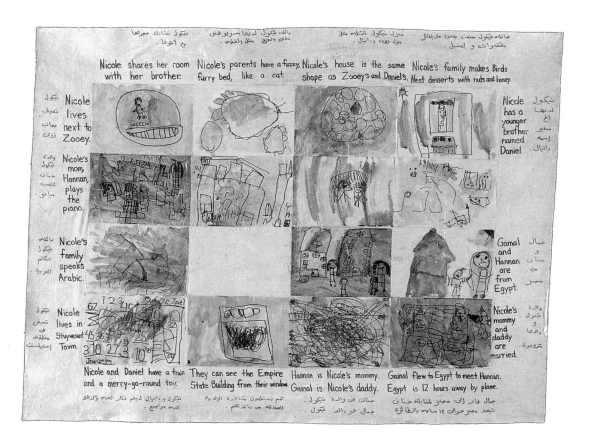

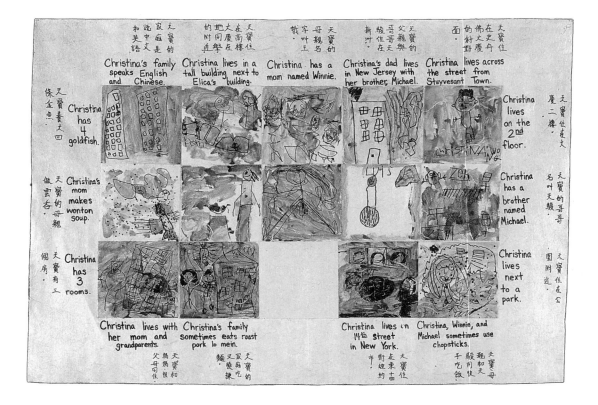

Superman doll next to his bed' to 'Cecily is lucky because she can watch her mom cook while she's taking a bath.'" (Cecily lived in a home where the bathtub was in the kitchen.)

The class went through this same process eighteen times. Students drew maps of how to get to one another's homes and took pictures of the trips. For various reasons, some families didn't want an entire classroom to visit, so David improvised alternatives: He videotaped children giving tours of their homes; the class visited family members at their workplaces; and family members came to the classroom.

David's training was in early-childhood education, not art. Yet by applying all of the basic organizing principles, he had no trouble assuming the role of master artist and running a project from start to finish. He set a positive tone, came up with a workable framework, and the kids joyfully went along with him. During

story time, David paged through art books with his kids to stimulate their visual thinking. He tied the project into the very heart of the kindergarten curriculum. The children worked collaboratively throughout; the five- and six-year-olds gave input on everything from what to look out for during the visits to what colors to use in the paintings to the placement of each painting on each collage. They also helped design invitations to the closing event at the end of the year. It's always a challenge for teachers to get families involved in the classroom, yet everyone turned out for the culminating Celebration of Families—bringing along home-made Dominican, Polish, Egyptian, Italian, Chinese, and Spanish foods—with many parents and grandparents meeting and mingling for the first time. Each family took home a grand prize: a fanciful, one-of-a-kind collage of their own.

I've taken this collaborative art-making approach all over the world to different audiences of different ages. Every project has been unique; they've all been amazing. This approach works equally well with high-school students in Indiana; mothers and children in a homeless shelter in the Bronx; and faculty, staff, administrators, and students at a select four-year liberal arts college in Boston. I have no doubt that you, too, along with your students, can create astonishing art that you never dreamed possible. These projects are doable, the experience is powerful for everybody involved, the art objects are amazing, *and* this approach has tremendous potential for changing the place of the arts in education.

Read on. And make great things.

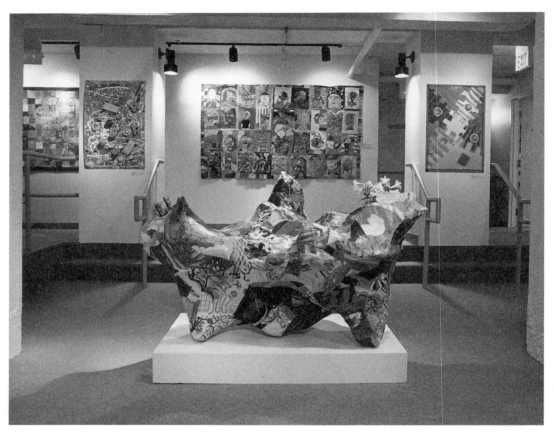

Collaborative art by elementary-school children and teachers fills a museum in New Bedford, Massachusetts.

Chapter Two

Teacher as Master Artist

"I never thought about art my whole life before this," a gym teacher, Nancy, told me. We were sitting outside the New Bedford Art Museum at a reception for an enormously successful exhibition of collaborative art made by elementary-school students. Hundreds of kids had filled the museum with large-scale two-dimensional collages and thousands of transformed shoes. Nancy had been instrumental in helping to pull off this project, a Herculean effort in a school district with little or no funding and little or no support of the arts.

Susan, a science teacher in East Hartford, Connecticut, was skeptical at first. Like Nancy in New Bedford, Susan had no art background whatsoever, but she was determined to build community in a neighborhood that was fractured by gangs, violence, and poverty. Along with six other teachers, she worked with sixty high-school kids to create a five-part, three-dimensional puzzle that dealt with the aftermath of 9/11. She was astonished by the way this collaborative approach brought kids together.

With no small degree of tentativeness, a computer science teacher at a middle school in Queens decided to join a collaborative art project in a limited way to create small-scale computer-generated imagery related to the topic Getting Along: smiles, geometric people, handshakes, and so on. Thrilled by the work her students produced, she decided to throw her full weight into a collaboration throughout all five boroughs of New York City that wound up in the Whitney Museum.

The mere idea of acrylic paint intimidated Juan, a fourth-grade teacher at an elementary school on Staten Island. He was also at his wits' end in dealing with a notoriously tough group of students. He was able to gather the focus and enthusiasm of this unruly group and help them make a large, painted hanging mobile that was exhibited at the Newhouse Center for Contemporary Art.

Despite vastly varying experiences and comfort levels with art-making, each of these teachers took on the role of master artist and succeeded in creating a large-

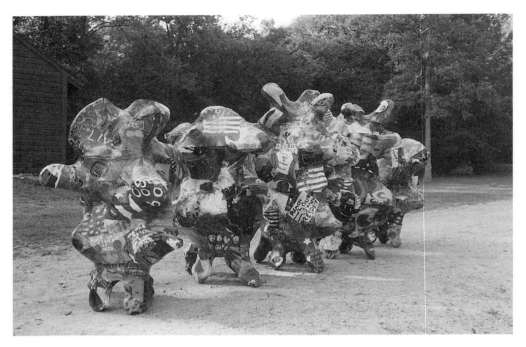

Interlocking sculpture pieces in East Hartford, Connecticut, made by high-school students.

scale masterwork with kids. So can you, whether or not you've ever picked up a paintbrush. I'm going to walk you through a set of *attitudinal* and *practical* steps that will equip you to begin.

Defining Terms

There are several key things you need to know before you actually do a thing to set a project in motion. Before meeting with your class and introducing the idea of collaborative art-making, before buying paint, brushes, canvas, and other art supplies, before setting any deadlines, before enlisting collaborators, funders, and advocates, you first need to make sure that you see yourself in a specific light: as an artist, a master, in charge of a creative project.

Shrouded in mystique—a mystique artists themselves have encouraged over the centuries—artists are sometimes believed to operate on another (higher) plane and to be endowed with innate talents and special gifts that the rest of us lowly

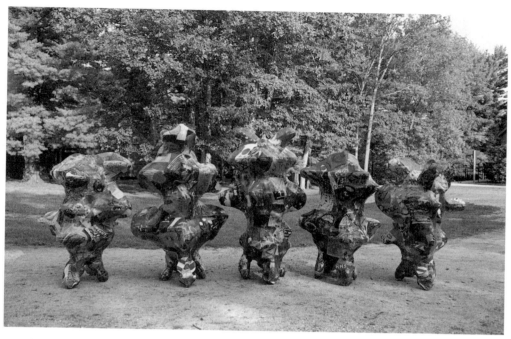
Another view.

beings don't have. At the least, most people believe that artists are born, not made; either you have the artist's gift or you don't, and art is the unique province of the gifted.

This is a particularly Western viewpoint. Generally speaking, in the East artists aren't revered as geniuses but traditionally as artisans who replicate the past; in fact, if an artist shows too much individuality, he or she is regarded as too egoistic to warrant respect. The island nation of Bali is an interesting example, a society where a large percentage of the population participates in creating art—the elderly, the young, shopkeepers, laborers—through dance, gamelan, or making a humble daily offering to the gods. Villagers don't commission professionals to build or adorn shrines for them: They build and imbue the shrines with meaning themselves. There is an active shrine in front of every building, from the humblest home to the fanciest tourist shop, and almost everyone thinks and lives the artist's life as part of Hindu religious practice. Moreover, while the Balinese may have

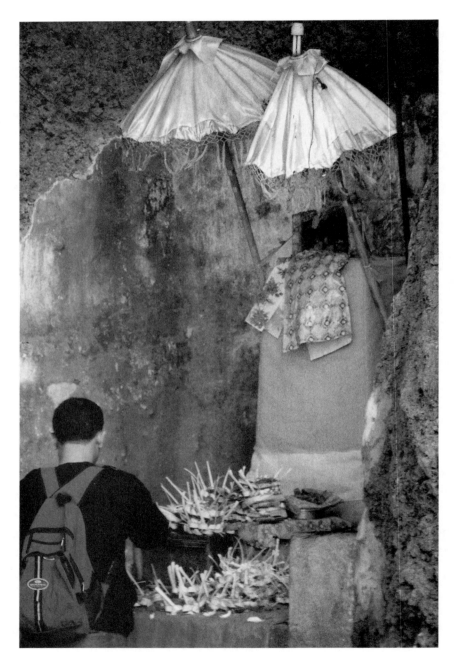

Person attending to an outdoor shrine in Bali.

Roadside shrines in front of houses.

personal favorites, they don't make judgments—"This is a better shrine that that!" "That's the best shrine!" "That's the worst!" Art-making for them is about the process, not the final product.

So right here at the start, I implore you to let go of the old, very *un*helpful idea that only special people make art. Don't let the term *master artist* scare you! Even if you've never taken an art class, you can lead a collaborative art project with kids. *Master,* in this case, doesn't mean you can paint like da Vinci or sculpt like Brancusi. It does mean that you understand that everyone—yourself included—is visually literate simply by virtue of being born with two eyes and living in a visually rich culture. It also means, most basically, that you take responsibility for leading the project. You procure supplies, you set the schedule, and, just as all teachers do every day (consciously or not), you decide *how* decisions will get made: by teacher mandate, by student consensus, through democratic elections, and so forth.

In fact, a master artist and a skillful teacher are essentially one and the same thing. There's only one key difference: a master artist is making art. That means there are basic things to know about materials, about the temperament of paint, about glues, about how to collage, about how to frame and present a finished work. The appendix walks you through these basics, and there are countless other resources you can draw upon. Traditionally, a budding artist apprenticed with a master, learned all he or she could, then became a master him- or herself. A Renaissance artist's workshop had dozens of people working in it, as busy as any classroom. If you're new at this, kindly think of yourself as my apprentice. This book can serve as your apprenticeship. As you read through the chapters and learn how to put the five basic principles into action, you are taking a crash course in Master Artistry.

Visual Literacy

You've been enrolled in a visual arts apprenticeship from day one. Every minute of our daily experience involves visual evaluation. It starts early: the mobile over your crib, the colorful letters of a child's alphabet. Even today, you're evaluating what you like and don't like all the time: clothing, hairstyles, advertisements on TV, people's yards, cars, and on and on. When you go to the store and you choose a green shirt over a blue one, you're making a visual decision. When you decide where to hang decorations on a Christmas tree, you're making visual decisions.

When you decide how to write *Happy Birthday* on a birthday card, you're making a visual decision.

I invite you to revel in your visual literacy—and trust it. If no one's ever given you permission to trust your own visual instincts, give it to yourself! I'd wager that not only have people not given you permission but also that any number of self-righteous individuals—art teachers, art critics, art connoisseurs—have claimed ownership of the "proper" interpretation of the visual world. Certainly these people have expertise and ideas to offer us, but this should never be at the expense of our own critical visual thinking. When I teach students who are liberal arts majors (not art majors), I constantly hear "I'm not creative, I'm not an artist." These are smart students at top liberal arts colleges. Where in the world did they get these ideas? Some may have parents who told them that their drawings of the three-legged horse, the crooked house, or the orange sky were wrong. Others may have watched friends with more traditional skills get singled out as artistic.

Even today, at the dawn of the twenty-first century, we're still trying to shed the conceptions of the Renaissance. The successful Renaissance artist had highly refined skill, akin to highly developed athletic skill, to render refined portraits in perfect perspective. Don't get me wrong: It's a remarkable feat. But the achievements of Leonardo and Michelangelo and Botticelli shouldn't paralyze us. We can become so fixated on skills that we mistake these for creativity. (I'll have more to say about the liberating effects of contemporary art in chapter 5.)

You, like everyone else, have an artistic voice; it's a matter of finding the style that suits you. Some people are much better at drawing realistic images, while others are better with geometry or with abstract colors that reference emotional states of being. Even if you don't draw or paint or sculpt, I'm sure you draw on your innate aesthetic sense in everyday ways. How you set your table is a form of aesthetic expression. Working with wood, or sewing, or making an elaborate meal, or growing a beautiful perennial garden, or dressing with flair—all of it is your art, even if you don't recognize it as such.

Here at the start, I want you to own and accept that you are visually literate. This doesn't preclude learning more. You can always learn new techniques and experiment with new materials. You can read books and take classes on the color wheel, on perspective, on construction, on tone and hue, on modeling. That kind of study, however, is not required to lead these projects. More important is the per-

mission you give yourself to revel in the visual literacy you've already developed, perhaps without even knowing it. Once you've claimed ownership of your own creative and visual powers, then you're in a position to pass that permission and enthusiasm on to your students.

Seeing: An Assignment

My nine-year-old son, Jack, is obsessed with the shape of the wasps' nest hanging on the back deck. His friend Amanda recently counted fourteen colors in a single sunset. I invite you to take an afternoon, or even five minutes, and, like these kids, revel in *seeing*. Consciously exercise your powers of observation. Observe the shadows in your room. Perceive the bubbles in a glass of mineral water. Behold sunlight glinting off water. Pick two dandelions or roses or leaves from a single tree and see how they differ from each other. Look at the world upside down.

Here's a simple, childlike technique I sometimes use. Take your thumb and index finger, join them in a circle, and use this as a viewer. Close one eye and notice only what you see within the circle of the frame, putting aside what you think you already know about the larger context. Look around the room with your viewer. Notice the colors. Notice the shapes. Notice the lines.

Look at the sky and see three stars. Observe the moon every night and do a drawing, starting with the shape of the moon. Can you imagine assigning this topic to your students?

Try to see how many different shades of green you can notice in fifteen minutes. Once I say *green*, your mind can't help running with it and seeing green, in all its shades and hues, everywhere. There's a fundamental difference between thinking about something and actually experiencing it: the difference between the conceptual and perceptual. I want you to practice perceiving. I don't want you to *think* about green, simply *experience* green.

I can describe how it will feel to shake your hand, but this is never how it really feels. Because shaking a hand—or wiggling your toes, or pressing your tongue against the inside of your cheek—affects many different visceral senses that can't be described in language.

Josef Albers, a renowned art professor at Yale, dedicated his life to understanding color and color relationships. He wrote *Interaction of Color,* one of the most important books ever on color theory. Albers assigned his students simple exer-

cises: Paint two canvases of exactly the same size in the same color blue out of the same tube of paint. Then paint a small square in the center of each canvas; make one red, the other orange, and notice how the blue is affected by these differently colored squares. Now shrink the red square to a third of its size, and notice how it affects the blue differently. Now put the red square in the right corner, and see how this affects the blue differently. Albers gave assignments like this hundreds of times, but he could never *explain* the sensory experience to his students: they had to experience it for themselves. He might be able to say that complementary colors do one thing, contrasting colors do another—but only generally. Albers's goal was to have students *feel* and *sense* the color intuitively, not to offer them a hard-and-fast set of rules. He wanted his students to trust their own sense of colors, rather than searching for some magic answer *out there*. Likewise, as you consciously practice seeing, I want you to develop confidence in your own visual sensibilities. Of course, there's a double payoff in doing exercises like these: As you gain visual confidence, you'll be in a better position to help your students to see too.

In the Thinking Through Art program at the Boston Museum of Fine Arts, fifth-graders visit the museum, look at art, talk about what they've seen, and make art in response. The underlying belief is that simply by sitting in front of a painting or sculpture—and letting that painting or sculpture work on them—the students are able to see, intuit, and then express what these objects are about and how they work. Are they about heroism? Are they about quiet, transcendental moments? Are they about crazy energy and exuberance? And what about the work makes this so? An important part of your job as a master artist is to participate with your students in this kind of seeing. You say, "The orange in that painting really makes me feel warm and comfortable." And somebody says, "If we add a little blue, it will scream off the canvas and play off of the orange." It's good to have opinions. *And* it's good to be open to new ideas. You say, "I like this painting three feet tall." A student responds, "But what if it were nine feet tall? It would be way more interesting." And you realize that that's a good point! Suddenly you and your students have had an exchange of artistic ideas that started simply with seeing and then talking about what you saw, and then challenging preconceptions by imagining how things might be different.

Scribbling and Soul

Being a master artist in collaborative art with kids means that you are willing to accept everyone's artistic contribution without prioritizing or passing judgment. A kindergarten teacher opens up a box of crayons, hands the crayons to the students, and trusts that they'll make interesting marks on paper. Your project can be that basic. You're asking your kids to do what they already naturally do: draw or write their ideas with the materials you give them. Buy jars of acrylic paint (brushes are easily washable in water), open them up, and start your students painting. Sometimes it's challenging to get eighth-graders to take that uninhibited kindergarten creative leap. Do your best to create a space where they'll feel comfortable taking risks. Begin by telling them, "Anything goes." Have conversations about things they can do with their paintings—add stripes to a solid background, outline a yellow flower with dark green or black to make it pop—but even if they just scribble, the final product will be visually engaging. Imagine the scribbles of thirty kids tiled on a huge sculptural number 5 or a giant globe: This is visually engaging. The framework—the number 5 or the globe, in these examples—is what gives kids' different expressions, however basic, greater meaning and impact. (Much more on this in chapter 3.)

We quickly forget how much we enjoy the creative efforts of young children, their scribblings, their doodles, their primitive take on a face. Most parents fall in love with their child's drawings, rarely because of the mastery with which they're drawn but because of the love they have for their child and for his or her expression, regardless of the form it assumes. Similarly, a key part of your job is to appreciate each and every student's expression. When Sylvie isn't ready to draw a face and insists on scribbling, accept that. In fact, do your best to see the *soul* in that. Know that Sylvie's scribble is every bit as important as a perfectly rendered face, and every bit as expressive of her mind. Every voice in the collaboration has merit and every contribution will add to the visual language and power of the final piece; it's the combination of voices that's magical. Trust me: When the kids' expressions are put next to one another, they will create an intriguing visual story. I'm asking you to do the equivalent of seeing the beauty in every human being, the humanity in each one of your students, even and especially when a student is difficult. Of

course, you can and should make suggestions, as becomes any skillful teacher, but without harsh judgment.

Obsession and Discovery

Collaborative art projects are powerful educational experiences because art itself is a means of finding out about the world, a means of investigation and of discovery. All artists, even decorative artists, explore concepts they want to communicate with their art. The concept might be serious and political, or humorous, or concern itself with geometry and form, or simple decoration. Matisse once commented that he wanted his art to be like a "comfortable armchair"—by no means a high-minded concept, but certainly an evocative one. Whatever the concept, artists work in *purposeful* ways. Akin to writers, artists pose questions and make arguments, in this case visual arguments, with their work. Most artists I know become outright obsessed with their arguments and topics of investigation. I'm obsessed, for example, with the collision of cultures and how meaning changes over time. Andy Warhol was obsessed with representing everyday popular cultural icons. Picasso famously went from obsession to obsession: from the blue period, to cubism, to portraying himself with his models. Young students, akin to Warhol, are typically preoccupied with popular culture and often become obsessed with cultural icons—Pokemon, say, or a peace symbol. The challenge is to help them find a new way of seeing and communicating what is often a cliché. The peace sign might become a mask, for instance, while Pokemon might be part of a larger, zanier pattern. Your role is to help students take the image out of realm of cliché, or Madison Avenue, and bring it into the realm of exploration.

Remain open to discovery! If you think of art projects as investigations into larger questions—ideally, linked to students' studies or interests—you'll be able to say a lot more with the art. For me, the best art is both personal and universal; an individual's concerns and concepts relate, to some degree, to everybody.

Now that you've gotten some basic attitudes in place—you trust your visual sense; you've put aside preconceptions about what artists are; you understand art as a form of exploration; you've set your judgmental mind aside—let's move on to practical matters. How can you use these attitudes in the classroom to guide a successful project of collaborative art-making?

Master Artist/Capable Teacher

If you're a teacher, you already know what it takes to create and implement a successful lesson plan. You use your imagination. You're organized. You're comfortable conducting research and gathering relevant resources. You procure needed supplies. You set goals or pose essential questions for each lesson to answer. You know how to introduce ideas and tasks in ways that get kids fired up. You consciously work to engage both bright and slow students and find ways to involve kids who are easily left out. You use vocabulary kids can understand. You know how to break a large project into achievable segments and how to pace lessons to get things done on time. You know how to maintain order (or at least enough slightly chaotic order) so that learning and creative exploration can happen. Most basic, you're the leader, the one in charge.

These are the same skills and qualities you need to be a master artist. You don't have to be able to paint the Mona Lisa. You don't have to have invented Pop Art. You do need to be a capable teacher interested in making art. Interest is key, along with motivation, the desire to see these projects through, and the belief in your ability to succeed. Once you're motivated, whatever your artistic skill level, the rest is a cinch. If you have paper and pencils, you're set to go. If you have colored pencils or Magic Markers, you're ten steps ahead. On second thought, that's not true—you can create a wonderful project using just paper and pencils. Anything beyond that—understanding how to apply acrylic paint, how to construct a sculptural form, how to incorporate photographic imagery, how to make a billboard—is simple to learn and explained in the appendix. Remember, you don't have to figure all of this out on your own. Every artist I know, including me, relies on outside expertise whenever needed. I rely on engineers to determine the structural strength of beams for hanging mobiles, on foundry workers to make molds and cast bronze tiles from originals, on outdoor sign companies to produce graphic imagery, and on moving companies to help me move large sculptures. You can do the same. Consult with the art teacher down the hall, for example, about everything from scale to palette to glues, or ask a parent with excellent woodworking skills to construct a frame for your collaborative sculpture. Remember always to trust your own master judgment when deciding what advice to take.

Another thing I've observed about successful artists is that, by and large, they

get their working system in order before they begin: materials, concept, execution plan. The result is frequent success. Most of what they make is solid and quite wonderful. Every once in a while, when the stars line up, the artists shoot out of their orbit, and make something miraculous. On occasion, they flounder and make things that are downright bad.

As master artist, you're in charge of materials. You're in charge of the execution plan: the schedule and timeline. In this case, however, you may or may not be in charge of the concept. It's your job to determine just how democratic the working process will be: when it's most productive for you to supply the central vision for the project—"We're going to create a twenty-two-foot billboard"—and when it might be more productive, or important, to open this up to debate. Do you choose the topic for the artwork or do your students? Do you decide where the piece of art will be exhibited or do you give students the chance to decide? Any combination of decisions is fine, but it's up to you, as master artist, to understand whom you're working with and how best to orchestrate success.

If you've never made a soufflé, you look up a recipe and follow the instructions. You gather needed ingredients, the eggs, the butter, the all-purpose flour. You may not understand the chemistry and physics of emulsification, but if you follow and trust the recipe, you're going to wind up with a nice meal. After you've made a soufflé a number of times, you'll start to understand the technicalities, and maybe start to get curious about exactly what factors create a better lift. Just as there are different ways to cook, all of which can result in a delicious dish, there are different ways to run these projects and produce a magnificent end product. Some people will naturally start improvising, others won't. It's often a question of a pinch of salt—or the consistency of glue. If you've never done anything like this before, follow my step-by-step instructions the first time through. As you gain the tools and confidence, improvisation can follow.

An Exciting Studio Atmosphere

As I mentioned earlier, many Renaissance artists worked in teams. The master artist sketched out a drawing, and various preliminary steps were done by workshop artists: cloud painters, putto (little baby) painters, tree painters. The studio I'm urging you to create is a little bit like that, but more democratic. The teacher as master artist is in charge, but the students work in a shared space with a huge

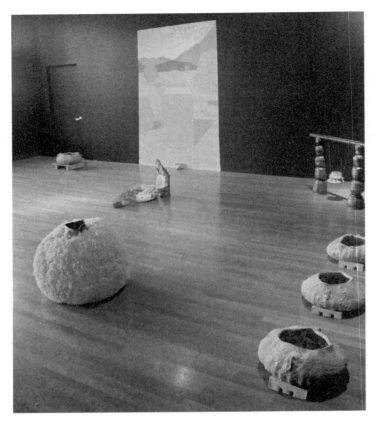

Mark Cooper, Sophomore Interventions, installation with Taylor Davis's MassArt class.

amount of creative autonomy. In this case, rather than painting prescribed clouds and trees, the students come up with imagery of their own.

Just as space is important to every adult artist I know, it's key for kids as well. It's important to create the most positive, benevolent, exciting working environment possible for your students. For most artists, the studio is their haven, their oasis. Aim to create the same for kids. Make sure you have all of the materials you need, and set these out for students in advance. Turn the studio over to them as theirs—to come and go as they please, to keep clean—while you make sure everything functions. Ask them what they want: more red paint, more colored paper? Discuss what it takes to run a studio, to buy materials, to maintain every-

thing. Give students choice and freedom whenever possible: Do you want to be in groups of two, three, or four? Do you want to stand up at the table while you work, or sit down? Encourage students to talk and help each other out. Constantly remind them that you have one opinion and that they should seek out others. Create studio mystique. Put up pictures by other artists. Put plastic on the tables. The mere act of doing this turns the room into a workshop. The five minutes you take to enter the world of the studio, even if the students never physically leave the room, helps create special atmosphere.

Work Attitude and Ethic

I believe in the power of teaching by example, by osmosis; not only artistic techniques, but work ethic as well. To begin, your students need to see you, as master artist, commit wholeheartedly to the project. Convey the intention that this collaboration will result in wonderful artwork. This attitude alone isn't enough, of course. You need the physical framework, the right materials, an organized

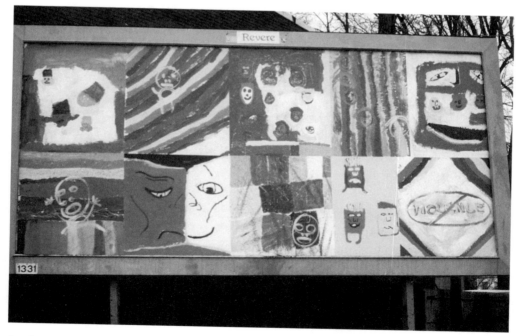

Student-made billboard, Washington, D.C.

classroom, and the rest. This won't be accomplished by wishful thinking. But with everything else in place, a winning attitude will carry you farther than you'd go without it. As simply and clearly as you can, state your intention to your students. For example, "We're going to make an incredible mural for the school." "We're going to make a fantastic sculpture that's going to live outside on the playground." "We're going to make an amazing billboard for our neighborhood. Together we'll decide what it will be about and how we'll make it."

When I teach ceramics to college students, I demonstrate on the potter's wheel. I can throw a pot in a blink. But don't be fooled, I tell my students. It's like watching a kung fu movie where the kung fu master throws someone across the room: He makes it look effortless. And so it appears with the pot, but in actuality, I'm totally focused and my *intention* is to make a masterpiece, even if it's only a simple bowl. While using a wheel does require a certain degree of skill, I can show someone in two minutes how to make a pinch pot, and he or she can make wonderful objects right away *if* the focus, attention, and intention is there. I'm constantly trying to strike a delicate and crucial balance with students. On the one hand, I encourage them to aim high, to aspire to something that really sings—and in response, they become focused and determined. On the other hand, I encourage them to remain ever open to discovery, to have fun, to play—and to risk falling flat on their faces!

And yet, despite each student's reaching for excellence, these projects aren't competitive in the least. Students don't vie against one another, against another class down the hall, or against students across town who are also making a collaborative piece. There's room to fill the planet with wonderful art, and every individual simply contributes the best he or she can. There are very few opportunities in life where an entire community, be it a single classroom or an entire school, comes together in a noncompetitive way to make something really fantastic for the good of all. These projects build trust among students, between students and teachers, between parents and teachers, and between parents and kids, adding up to one powerful community-building experience.

Decision Maker

One thing's certain: As master artist, you need to be prepared to make a ton of decisions. Practical decisions, such as what materials to use and how ambitious to be

in terms of time and scale and expense. Conceptual decisions, such as what ideas to express and what areas of the curriculum to tie the art to, if any.

But the first, and arguably most important, decision that you need to make—or that you and your students will make together—is what you want to create. What will the framework for the students' artistic expressions be? A billboard? A sculpture? A mural? A mobile? This frame is key to the process, providing the literal space that students work within. Without it, they couldn't create something together. With it, fascinating and exciting possibilities open up. The next chapter examines the factors you need to consider when deciding on a framework for success.

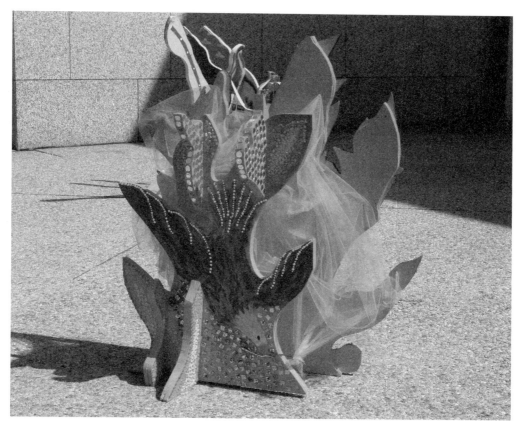

Boston College Set the World on Fire project, Vietnamese Student Association.

· FEATURED MASTER ARTIST AND TEACHER ·
Betsy Damien

Betsy Damien has been teaching kindergarten for more than fifteen years at the Tobin School, a Title I school (meaning, among other things, that more than 50 percent of students receive free lunch) in Cambridge, Massachusetts, where, Betsy says, "The thinking tends to be about kids' deficits, instead of their strengths." In 2000, Betsy contacted me to lend a hand. While she and her colleagues had been working with students in their school's art room for some time, they didn't have the knowledge or the confidence to make a large collaborative piece of artwork.

She wound up devoting four years to making collaborative projects with her four- and five-year-olds. The first year they made free-form machines and the inner workings of a fantasy factory out of found objects. The factory itself was an open, wooden, dollhouse-like architectural form embellished with collaged student drawings. Inside, students housed their fanciful machines and in the "library" their journals. The following year they made mixed-media starfish decorated with small treasures—buttons, strings, feathers, screws, seedpods—that the students had collected. Since then, teachers-in-training from Lesley University have come to study Betsy's classroom. "What does a teacher need to know to do collaborative projects with kids?" I asked Betsy. Here is her advice.

1. **Trust the kids.** With younger kids, it's my experience that you have to give them time to just mess around with materials, let them be, ask them questions, and listen to what they're saying. Don't have an end in mind. Once you find out what the kids are interested in, your job is to help them get there. Feed them back their ideas: "Look at what you did yesterday. Do you want to do more of this? Do you like the way it is? Does anybody in the class have anything to say about this?" Encourage conversation around the work and this will naturally lead to the next step. Somebody paints a rainbow at the easel and, during sharing time, other kids pipe in: "What if you use these different colors instead tomorrow?" Multiply this by the complexities of children and you wind up with an incredible piece.

Kindergarten factory structures, Tobin School, Cambridge, Massachusetts.

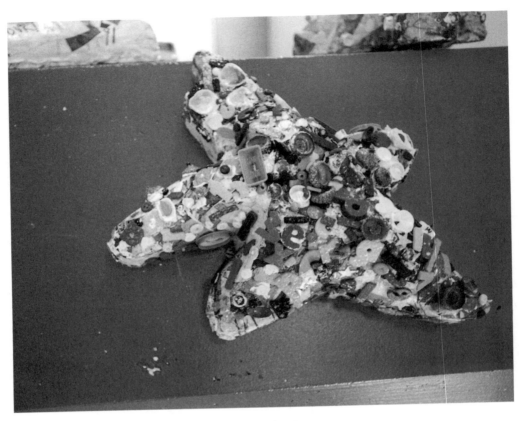

Starfish sculpture project, kindergarten, Tobin School.

2. **Reinforce students' interests with books, field trips, and activities in the classroom.** When we made our furniture factory, the class walked up the street to the "bread factory," a local bakery. We took photographs and posted these around the classroom. Field trips make a project so much richer. Also, give kids a common experience, and they have a shared history.

3. **Be able to defend yourself. How is this artwork serving the goals of your curriculum?** More than likely, some people will question the value of spending time making art. Be assured: What you are doing in your art studio is more than the curriculum could ever supply! Research suggests that we can articulate only 20 percent of what we know; every time students articulate

what they know through a different medium, they gain in knowledge. People think art is fluff. We should use the word *science* instead. Art and science are both about figuring things out. Art is about math too. And literacy. While students make art, there is profound *learning* going on.

4. **It's necessary to have some working knowledge of your materials.** Start with what you know, pencil on paper, and build from there.

5. **You can only expect students to do what they are capable of doing.** Very carefully assess your students' capabilities and skill levels. Play to their strengths, while keeping in mind their limitations so you don't inadvertently set them up for failure. When we decided to launch the starfish project, we had two types of students. Some were still messing around with materials, especially the four-year-olds, while another group was creating incredible stories. So we decided to make the starfish in two steps: The first group of kids made the first layer of collage, and the kids who were more interested in expressing themselves did the design work and applied found objects to the fish. In this way, we made it possible for all students to participate and feel successful.

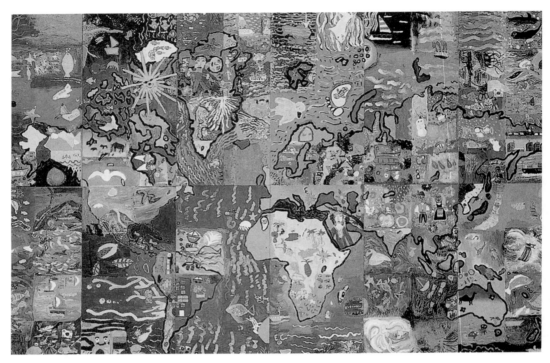

World map created by sixty-five young students from around the world, in a project sponsored by the International Child Art Foundation.

Chapter Three

Molecules to Masks: Frameworks for Success

A teacher hands you a blank piece of paper and says, "Write about anything you want." If you're at all like me, your mind comes up blank. Another teacher prompts, "Write about one of your most prized possessions," and you're bursting with ideas. The first prompt is too open-ended; there's no structure to hang a thought on. The second, by imposing form, propels the mind to motion.

Picasso once said, "If you have ten colors to work with, only use three so you really stretch them." The limitations provided by structure and form open up larger possibilities in the realm of creativity. It's the same in so many aspects of our lives. Take walking: You need a skeletal framework to stand erect and move about in any purposeful way in the world. Take checkers: You need the form of the checkerboard and the framework of rules to structure the play of the game. Take productivity: You're not getting anything done, so you set a deadline and are propelled into constructive action.

This idea of form or framework is, like any good educational idea, just re-packaging what you already know as a teacher. You don't teach physics (or reading or history) all at once, in random order; you teach specific concepts and skills in a step-by-step deliberate manner utilizing organizing tools such as assignments, deadlines, tests, daily classroom rituals, pedagogical tricks of the trade. These create a framework for learning, without which students would flounder.

The same goes for a collaborative art project. Your kids will be more creative, and the resulting artwork more fantastic, if from the very start you give them a sturdy framework to work within. Two types of frameworks are indispensable. One is the attitudinal framework: You set the intention to make a great work of art and believe you're going to succeed, which you've already assumed along with the role of master artist. The second is the physical framework, or form, of the art-work: a mask, mural, dollhouse, puzzle piece, sculpture of a number 5, a snail, or any other conceivable shape that serves as an organizing principle for a project.

For a project in New Bedford, Massachusetts, the physical framework was shoes. Grade-school kids collected shoes, painted them, and then attached buttons, cans, colored string, seaweed, and fishnets to the shoes. They made a mountain installation of shoes. At the International Child Art Foundation in Washington, D.C., the framework was a giant world map, measuring 16 ft. x 36 ft., onto which kids from sixty-five countries drew pictures of their wishes and concerns for the world as we entered the twenty-first century. A framework, because it has its own visual integrity, allows participants with vastly differing artistic skills and styles to collaborate successfully.

Artists and Frameworks

It's commonly assumed that artists don't need frameworks; that artists, those free-thinkers and creative geniuses, eschew any kind of structure. Nothing could be further from the truth. All artists work within parameters and set short- and long-term goals for the body of work and ideas they are pursuing. Like teachers, artists have to decide what they are going to say and how they are going to express themselves. When an artist runs into a stumbling block, it's usually because he or she is confused on one of these points. In the most successful works of art I've seen, there's *clarity* on both points, even if this isn't apparent at first glance.

Take Jackson Pollock, the drip painter, for example. It may seem like any six-year-old kid could create a Jackson Pollock. While it may be true that anyone could lay a canvas on the floor and squirt paint all over it, what made Pollock a master was his ability to harness and express compelling emotional and psychological states. For his framework, Pollock chose giant canvases on which he dripped layers and layers of paint. Many of his canvases are so large, you can't take in the entire painting from any one place; instead, you are physically and emotionally immersed in the expansive sea of a single painting. Pollock took representation out of art and went straight to underlying emotion; this is *what* he was trying to say. He also understood *how* to express emotion, the form required to succeed. His paintings wouldn't have the same impact if he'd done them on 8 in. x 10 in. pieces of paper. (While Pollock did make some small 5 ft. x 7 ft. paintings, these aren't what put him on the map.) In the same way, if you ask your students to make masks or portraits and put these on a 50 ft. x 50 ft. grid, the works pack a collective punch they couldn't possibly have had individually.

As you and your students embark on a collaborative project, you too have to decide, like all other artists, what you'd like to say and how you are going to say it. I encourage you, like Pollock, to think large, think impact, think emotion! The rest of this chapter is concerned with the *how*: the physical framework for the project. For more on the *what*, see chapter 6.

Leapfrogging to Masterworks

It may sound preposterous to hear that you and your students—even little kids who only know how to make the most basic marks on paper—will create a masterwork. If so, this bears repeating: While it would be great if everyone involved could draw gorgeously, that is unnecessary to create an extraordinary work of art. The collaborative nature alone of this endeavor makes your project exceptional. Add to that a dramatic form—a huge mobile, mural, sculpture, billboard—and your students are guaranteed to be seen and heard. Take a drawing from any student in your class, blow it up into a twenty-five-foot-long, ten-foot-high billboard, and display it in public. The scale, shape, and placement will completely change how people experience this drawing. Believe me, they'll take notice! Similarly, if you choose a world map as your framework, will it have the most impact if it's 3 ft. x 4 ft. or if it's 30 ft. x 15 ft.?

When you choose a strong physical framework for the art, you allow your students to leapfrog to masterworks: complex objects with well-conceived messages. The variety of textures and colors possible, the multiplicity of ideas, the focus on concept rather than technical skill, the scope and scale of the final product—these features of your collaborative project are all way beyond what one child alone could do.

Choosing a Framework

Once you've decided to make a collaborative project with your students and you've assumed the role of master artist, your next step is to choose a central framework for the project. First, you need to decide just how this decision will be made: How democratic will the working process be? Will you choose the framework yourself or invite students into the decision-making process? (See the next chapter for more on the selection process.) Also, you'll likely have to work within some constraints. For instance, if you decide to make a gigantic sculpture, be sure first that you have

the physical space to construct it, as well as needed money, time, materials, and the support staff to move and install it.

Here's a sampling of forms to choose from, each of which I've successfully used in the past. This list is by no means exhaustive. Let your imagination run wild, as you and your students invent new frameworks of your own.

BILLBOARDS

Everyone knows billboards. A billboard is an advertising tool, placed in a prominent place, to reach a broad audience. The message, presented through visual imagery, is contained within the billboard's rectangular structure. I've made more than fifty collaborative billboards, and it's thrilling to subvert what's normally used as product-advertising space into an art statement by young people. We're selling something very different!

There are two basic ways to proceed. The first results in an actual full-scale billboard. All you need is ten 5 ft. x 4½ ft. sheets of paper and student-grade acrylic paint (which can withstand any kind of weather). Billboard companies often provide the paper for free or can certainly tell you where to get it. Anywhere from one to ten kids can design each sheet. The paper takes up a lot of space, so if you don't

Billboards collaboratively made by students around the country.

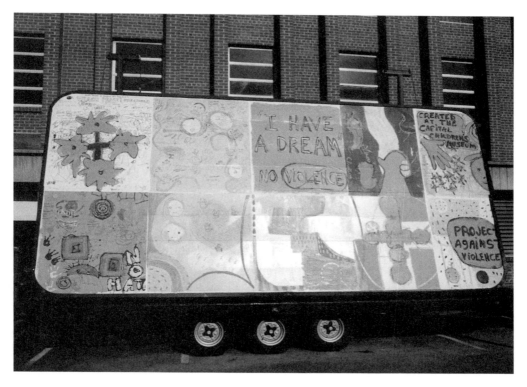

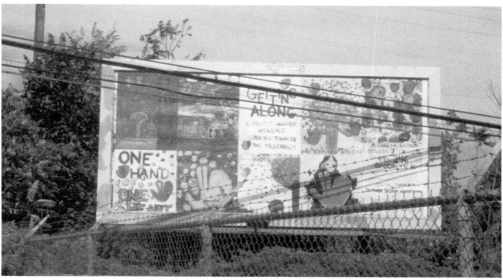

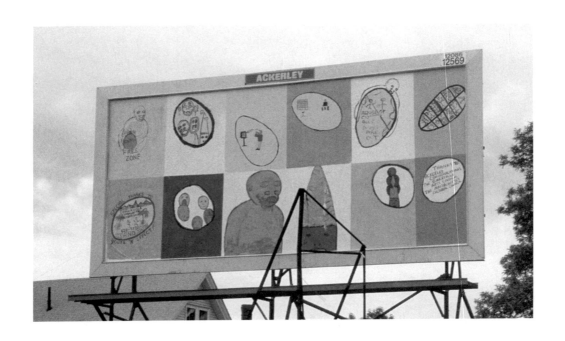

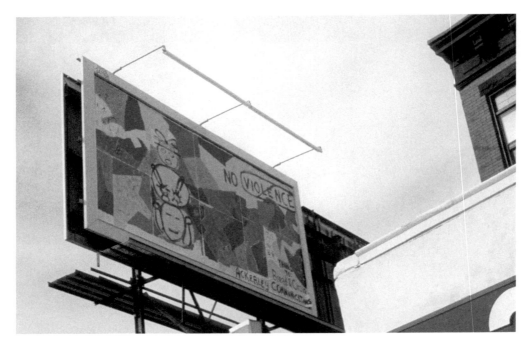

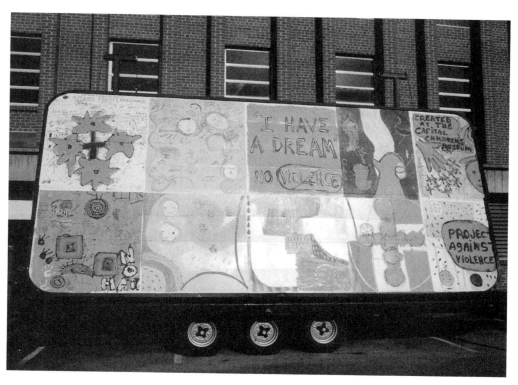

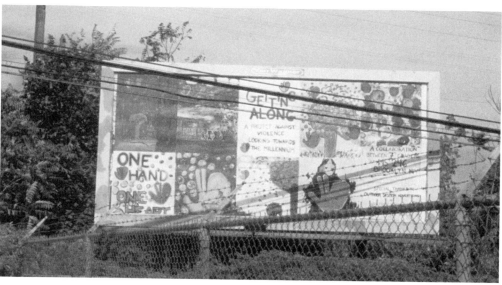

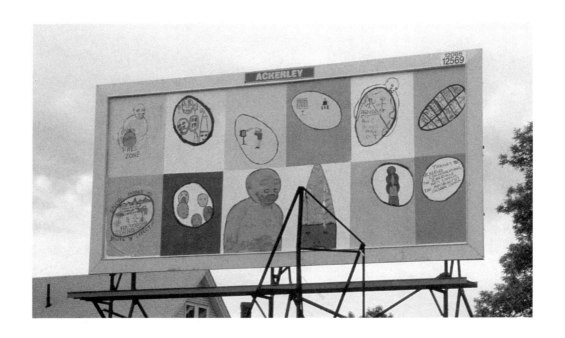

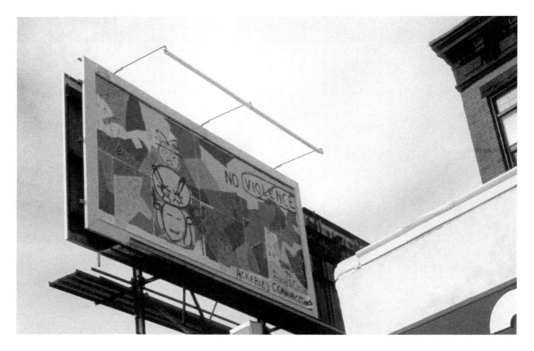

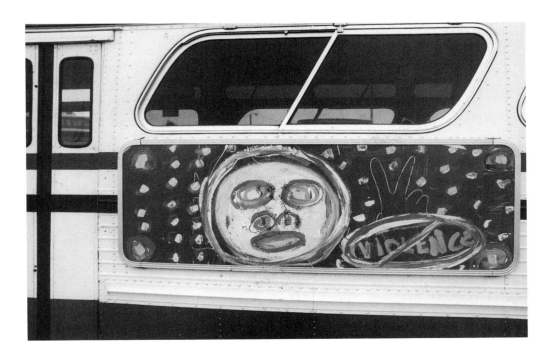

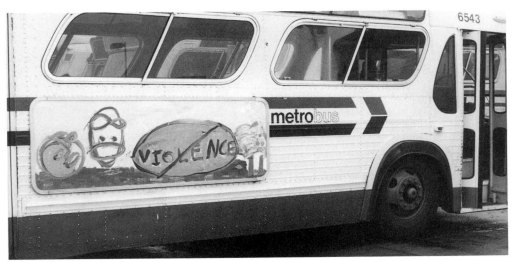

Art made by groups of students for sides and backs of buses, Stop Violence project, Washington, D.C. Signs made for buses can function similarly to billboards, reaching a very wide audience.

MOLECULES TO MASKS: FRAMEWORKS FOR SUCCESS ❖ 43

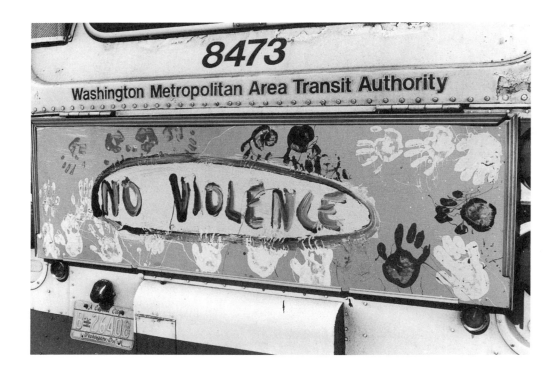

have room to spread out all ten sheets, work on one at a time. You can work on the floor, on a table, or tape paper to a wall. The acrylic paint dries within an hour, so you're quickly ready to deliver your final paintings to the billboard company, which usually will install your imagery on the billboard as a public service (for free), especially if you're flexible on time and location.

These days billboards are often created from digital imagery. Using this second approach, have kids paint on smaller pieces of paper; then, using a scanner, scan the paintings into a computer and save them as digital files. Billboard companies enlarge the imagery and post it up on a billboard. While this method won't give you the instant gratification of creating huge artwork, the thrill comes later when you and your students see your imagery blown up to mammoth scale on top of a building or at the side of a highway.

One of the first billboards I made was with teenagers in the Youth N' Effect afterschool program in Somerville, Massachusetts. We used the large-sheets-of-paper method. The kids decided to make a series of circles and paint within them,

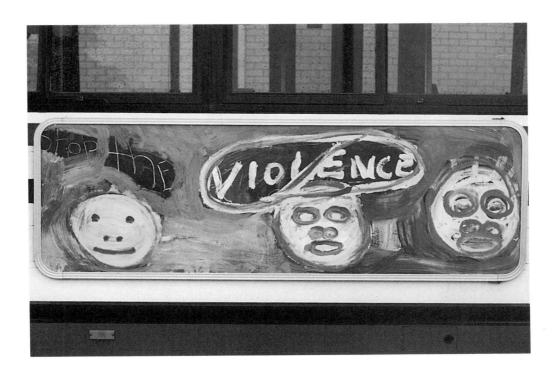

three circles per big sheet of paper. They painted big yellow circles and filled these in with bright blue background. Each student then painted an image in the circle relating to one of several themes, including Getting Along. I asked students to avoid clichés and not to paint imagery of knives and guns; they'd need to find other ways to speak up against violence. One group of kids painted cheese-doodle shapes all over their billboard in different colors and then added a big dark purple question mark with the word *violence* underneath: "Question Violence." Another group filled their billboard with a series of double-headed people to represent two ways of seeing things.

If you decide to make a billboard, consider some basic questions before you get started: Do I have the space to create it? Do I have the materials to construct it? Do I have money to buy materials? Do I have the agreement of the billboard company to donate the space? If the answer to all four questions is yes, you're ready to go.

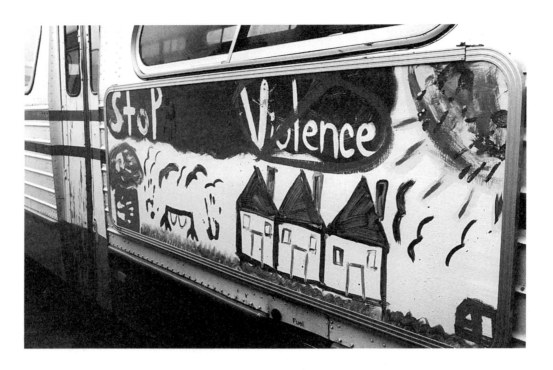

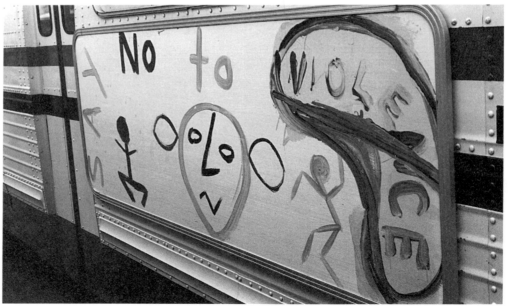

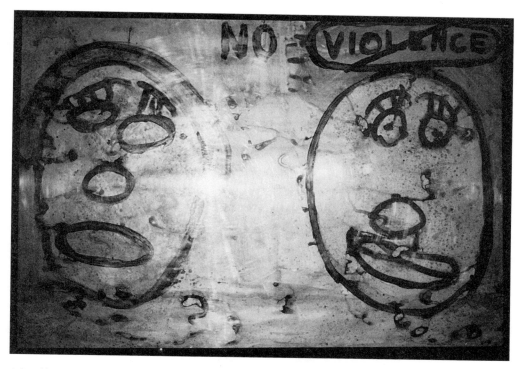

A backlit piece of collaborative art changes the meaning of a lighted subway advertising sign.

NUMBERS, LETTERS, AND WORDS

Recognizable shapes, like numbers and letters, make great frameworks. You can create a giant 7 or letter *Z* to tie in to a significant event in your classroom or a specific topic of study. For instance, if you're celebrating a seventh anniversary of some sort, use the number 7 as a framework. Play with this! Cut giant 7s out of cardboard, paint them, and hang them from the ceiling. Or make hundreds of small 7s out of paper and install them with pushpins to fill an entire wall. Get some Fimo clay (that can be hardened in your oven at home), have kids make sculptural 7s, decorate them, then march them down a hallway. You can work on the 7s throughout the year on the seventh day of each month.

If you welcome twenty-two new students at the start of the year, play with the

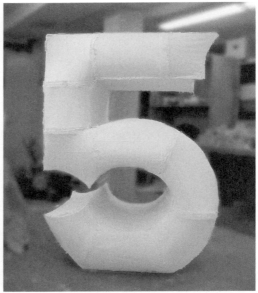

Variations on the number 5.

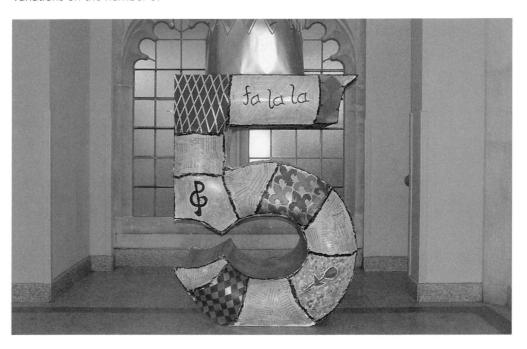

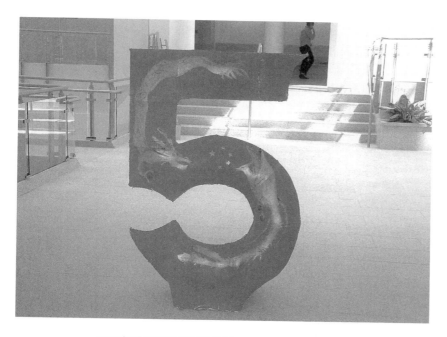

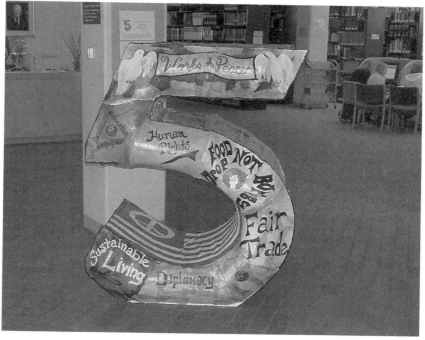

number 22. Create a mad-scientist blackboard painting of math formulas. Create a giant matrix of overlapping vocabulary words.

I saw a whimsical installation some years back based solely on the letter *A*. Jim Melchert made *A*s out of different materials: chicken wire, plywood, aluminum, ceramics. He drew *A*s on the floor, on the wall, and made an wild installation of *A*s in a gallery space. I felt as if I were walking into a painting. Imagine asking your class to fill an empty space with their renditions of the letter *W* or *Z* or *G*.

For the fifth anniversary of the Boston College Arts Festival, I created seventeen sculptural 5s that seventeen different campus groups then painted, collaged, and made their own. I started by drawing five-foot-high 5 forms on paper and then cut them out with scissors. I traced these onto plywood, twice per 5, and cut out the plywood shapes with a jigsaw. Next I cut several two-by-fours thirty inches long and screwed these to the inside of the two plywood 5s, making the sculptures around thirty inches thick (to fit easily through standard doors). Last, I stapled canvas to the plywood 5s to stretch over the space created by the two-by-fours and made sure the bottoms were flat so that the pieces would stand. I had reservations about this project; I feared the idea was too familiar and drew too heavily upon Pop Art. We've seen this before, I thought. But I was wrong. The shape of the 5 is so recognizable, the framework is so strong in and of itself, it could carry the different stylistic approaches of all seventeen groups. Some drew landscapes, others painted polka dots, one group glued a thousand paper dolls onto their plywood form. Also, each bare plywood 5 had its own nuances of grain, volume, and shape, even before it was decorated. (Imagine going to your computer and typing 5s in a hundred different fonts.) How often do you see a five-foot-high, three-foot-deep number 5? One now permanently resides in a UNESCO center in Paris.

Keep the symbol simple—a number, a letter, a single word—and be prepared to be surprised by the depth and variety of interpretations kids bring to it.

CIRCLES, SQUARES, TRIANGLES

Akin to numbers and letters, basic geometric shapes—circles, squares, triangles—are open-ended, productive idea generators. Kids can do whatever they want within them.

The Boston Schoolyard Initiative recently commissioned me to come up with artwork to revive miles of unappealing asphalt schoolyards and playgrounds. I de-

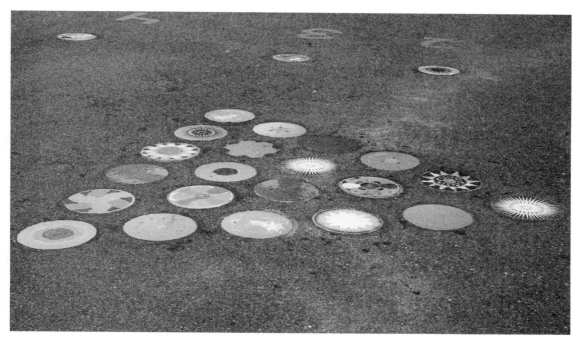

Circles on asphalt, Boston Schoolyard Initiative.

cided to polka-dot the Blackstone School playground (as a pilot site) with images and patterns that teachers could tie in to curricula and games. As an organizing framework I chose a circle, reductive and simple; so much else is already happening on a playground, I didn't want to add to the chaos.

I plastered the schoolyard with close to seven hundred circles, anywhere from one to three feet in diameter, filled with curriculum prompts for students of all grades. Some circles contained numbers and letters hidden within colorful patterns. Others featured digitally reproduced photographs of plants, animals, and mythical creatures that could be used as writing prompts. Others contain questions: "What do you dream?" "How have you helped the world?" Since the form is so simple, any teacher at any grade level can create more circles with his or her students to add to the playground or display in the classroom.

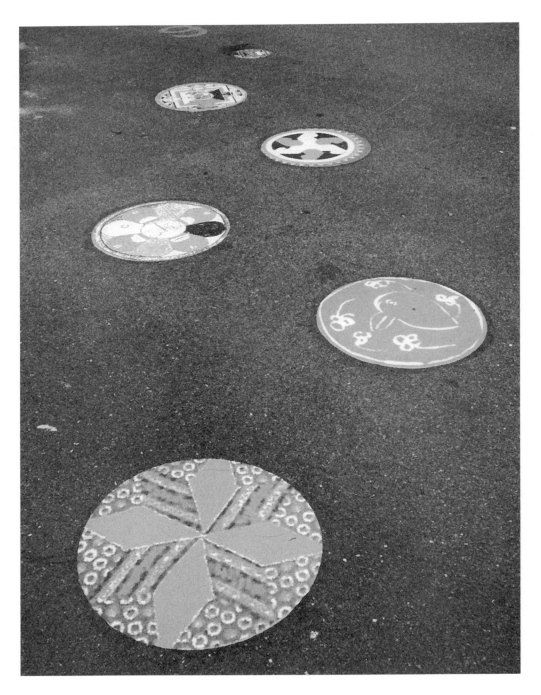

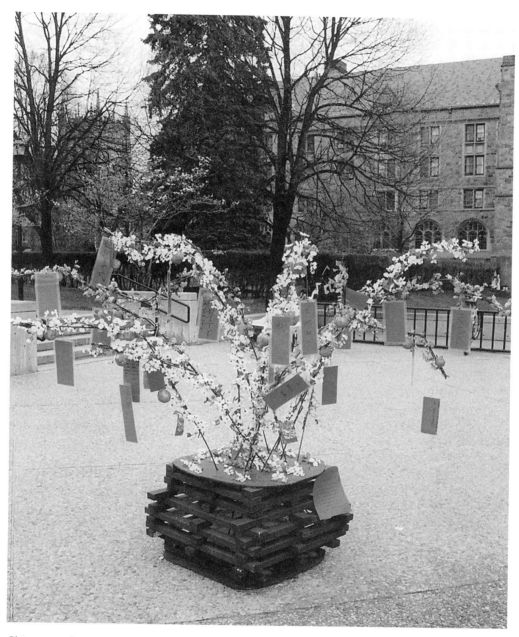

Chinese wishing tree, Boston College Arts Festival (the festival's theme was trees), made by college students through the Chinese cultural club.

If you have students from all over the world, as so many schools in America do these days, if you value multicultural education, if you want to teach kids about their place in a global society, more than likely you'll be using and relying on maps.

Maps, like numbers and letters, are meaningful visual forms we all immediately recognize and understand. Maps help us to locate ourselves in space and to know where we are; maps of the world, country, state, neighborhood, school, architectural floor plans, historical maps, and so on. Maps also record and organize *variation.* A map of the United States, for instance, can depict various states, population centers, voting records, land masses, bodies of water, immigration trends, and so on. Maps make great frameworks because they have recognizable visual integrity and are already imbued with meaning.

Let's say you want to work with a world map. Take an overhead or slide projector and project the map onto a 5 ft. x 5 ft. piece of canvas. Trace the map onto the canvas. You now have an outline of the world to work within. (You can similarly project onto canvas a giant portrait of Martin Luther King Jr., Marie Curie, or any other notable person from history to use as a starting place.) Now create a grid over the entire canvas: Grid every six inches from top to bottom and from side to side (in pencil that can be painted over) and assign different squares to your students. Of course, you can have kids decorate each delineated state, but as a practical matter I prefer to go with grids: Rhode Island would get painted much more quickly than Texas. Also, the simplicity of the grid allows for a range of skill levels; one young person might draw wonderfully ornate flowers in her square, another a simple blue background—and they both reinforce each other.

For the International Child Art Foundation, I worked with fifty elementary-school children, one from each state, to create a giant thirty-six-foot-long, sixteen-foot-high map of the United States. I outlined the national and state borders in black paint to give the map a strong, permanent frame, and then I made enough grids, over both bodies of water and land masses, for each child to get one grid apiece. I randomly assigned each child a grid and set three guidelines: (1) Depict imagery of your world in the year 2000; (2) Use blue and green as background colors for water areas; and (3) When you paint on the land masses, start with any

Collaboratively designed mural.

color *but* blue or green. Using acrylic paint, the kids depicted their world in great variation, including images from religion, sports, school studies, fairy tales, and folklore. Everyone attending the closing ceremony was enthralled with the result, U.S. senators included.

Most murals I see in public spaces, including schools, are numbingly predictable. Adults typically make the key creative decisions, starting with a realistic scene of people or animals. Kids sometimes get to help color in the scenes—a glorified coloring book!—with implicit or explicit directions not to stray outside the lines. Murals become exciting when the creators are given the freedom to do more than simply fill in the hat or the shirt or the hair with the most predictable color. Talk with students about how they will paint their grids. You may decide that everyone will do his or her own thing. Or you may decide that everyone will use four red dots in a section, or three specific colors, or that every section will include a phrase from a favorite poem.

Another compelling two-dimensional framework is the mask. Universal icons, masks have appeared throughout history and in almost every culture. Today, while

Masks, displayed in the Museum of Fine Arts in Boston. From a collaborative project with the Boston Children's Museum and the Boston public schools.

we wear actual masks perhaps once or twice a year, on Halloween or New Year's Eve, we don figurative masks all the time, masquerading as bosses, flirts, tough guys, ingénues, and so on. Literal or symbolic, masks allow us play with identity and explore hidden aspects of ourselves. All of these features appeal to young people as much as anyone, and masks provide interesting starting points for teaching. Create masks with your students. Make simple masks out of paper or cardboard. Up the ante with wood or plaster. Kids can take masks in a million different directions. They can swathe a mask with a single poem or with multiple math formulas, birds or buildings can fly out of the top of a head; the sky's the limit.

One very specific suggestion on making maps, murals, and masks: Ask kids to refrain from using their own names. Students tend to get preoccupied with their names and lose sight of other creative ways of communicating. Of course, every time I come up with a rule, we quickly come up with an interesting way to break it!

THREE-DIMENSIONAL SCULPTURES

Most people, when given the choice, opt to create a three-dimensional form over a standard wall mural. There's something arresting about a form that can hang from a ceiling, stand in a courtyard, or greet people in a building lobby. A few years back, an artist in Basel, Switzerland, created scores of identical, life-size, fiberglass cows in three positions: standing, kneeling, and lying down. The cow concept spread like wildfire, especially across the United States. Hundreds of artists in various cities painted cows that were then displayed in public spaces and eventually auctioned in fundraisers. The cows have been an unexpected hit with the public. They have made public art safe and accessible for many viewers who might have been intimidated by more abstract sculptures.

As a teacher, you have an open-ended range of possible sculptural frameworks to choose from, bovines included. You can create a three-dimensional form—a giant cow, a molecule, the number 9, or the letter *Z*—using a slightly more elaborate version of papier-mâché. Cut out wood (simple pieces of pine) with a jigsaw, screw pieces together into your predetermined form, then stretch and staple canvas over the form. Students paint on paper or cloth with acrylic paint, and then, with clear glue, apply their paintings onto the canvas form. If you're displaying the sculpture indoors, that's all there is to it. An outdoor sculpture needs to be fiberglassed to protect it from the weather and from people who are wont to poke, punch, and climb. You should also apply a UV-protective coating over the final product. (For details on techniques, see the appendix.)

If working with a jigsaw seems daunting, don't hesitate to put out a call for help to a skilled parent, local artist, or shop or set-design students in your local high school. While you're at it, contact the local lumber store, which will likely be happy to donate some two-by-fours, and the local paint store, which no doubt has gallons of mixed paint on hand that didn't suit their customers but will be perfect for you.

If you want to skip the wood construction phase, you can make a form out of chicken wire instead. Tape newspaper onto the wire form and then collage on top, using glue or wheat paste, as in traditional papier-mâché. More simply, you can wad up newspaper, tape it into a shape with masking tape, glue it with Elmer's or soba glue to harden it, and let it dry. You're now ready to collage right on top.

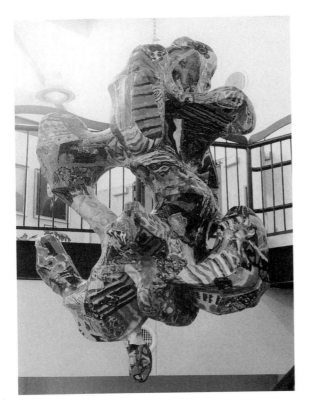

Bates Elementary School, Salem, Massachusetts. Large hanging sculpture on marine themes. Structure built to the collaborative design of elementary-school kids and painted by them.

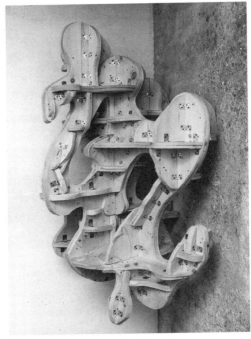

Substructure built for Bates Elementary School project, showing construction method.

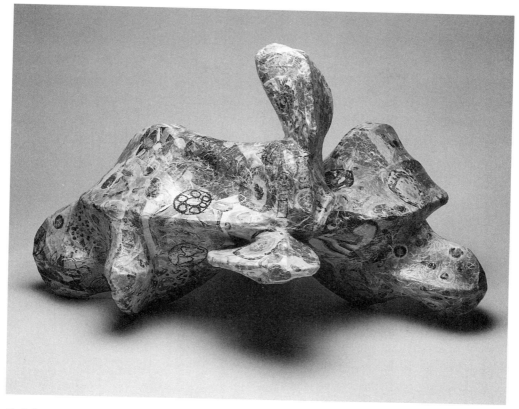

Collaborative sculpture, detail from installation at the Whitney Museum at Phillip Morris.

Puzzle pieces make great sculptures. In the Boston Museum of Fine Arts projects with five boys' and girls' clubs, each club created an individual puzzle piece that stood on its own as a unique piece of art. They also fit snugly together, and all of the pieces were exhibited at the museum, providing a rare opportunity for these clubs to come together in a noncompetitive, productive way. After the exhibit, each sculpture went back to its club of origin, along with wall text explaining the history of the project and photographic reproductions of the show. The result is not three-dimensional exactly but uses sculptural material to interlock the pieces in a plane. (See appendix for construction details.)

To make a puzzle piece, draw a large organic shape on a white piece of paper. Draw a puzzlelike line to separate the shape into two parts, and then cut out the

shapes and tape them to the wall with an inch in between. You now have a miniature working model. To make your puzzle pieces large and three-dimensional, cut huge two-dimensional pieces of cardboard into puzzle shapes, trace these onto plywood, and cut them out. If you're a math teacher, challenge your students to figure out the scale.

Imagine each grade in your school being responsible for a puzzle piece. If each piece is a mere three feet wide, when you put them together, suddenly you have a thirty-foot mural to hang in your school lobby. Puzzle pieces can also be recycled. For example, at one high school, each new freshman class got to make its own distinct mark on a puzzle piece created a previous year. Prime the piece first with white acrylic primer—literally creating a fresh start for the new students—then invite students to collage new drawings of hopes and dreams or some other theme onto the old form. Down the road, you can collage another new layer right on top of this one.

FOUND FORMS

Almost any object can substitute for a tube of paint and serve as raw material for a work of art. Students can bring in and work with natural forms such as pebbles, sticks, rocks, and leaves; or they can work with manufactured forms such as old forks, chairs, string, shoes, ties, and place mats.

In 1995, I visited Costa Rica as a juror for the competitive Art Biennial for Central and South American artists. While in San José, the capital, I came upon a display of small gold bells in a museum. The caption explained that literally thousands of bells like these hang in the trees in the rain forest. Imagine! The sweet, subtle chime of bells in the deep forest: I was inspired. I decided to create a variation on the theme for one of the First Night celebrations back in Boston. I made hundreds of small wooden forms reminiscent of spinning tops. Grade-school kids painted these with acrylic paint however they liked, and we then attached inexpensive, store-bought chimes to each hand-painted form. After getting permission from the parks department, I got a mega-ladder and hung the chimes from trees all around Boston Common. When they heard the quiet jingle of bells, First Night participants looked up in the trees and discovered the festive forms. Each object was quite wonderful in itself; massed together as an orchestra hanging in the trees, the result was pure enchantment.

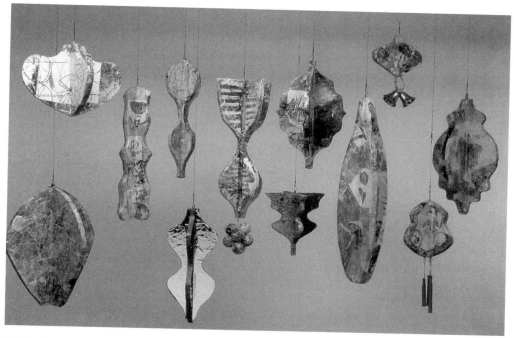

Wind chimes from Boston First Night project.

Your students can collect and work with one specific found form or with many. On Swans Island in Maine, where rocks are everywhere, kids at a summer program designed and created a painted rock garden on a beach above the high-tide mark. They collected big rocks, small rocks, those smooth black-and-gray rocks particular to the coast of Maine, and painted them in all colors of acrylics, then built and rebuilt different temporary arrangements of rocks. Imagine asking your students to collect and paint small rocks and then installing these in a giant spiral shape on the playground or in the gymnasium. Or, in lieu of rocks, your students could paint cafeteria plates, clothespins, pumpkins, or bottle caps. Individual painted bottle caps may be interesting, but a thousand of them, assembled in a meaningful way through a collaborative process, will amaze.

Students can also combine a smorgasbord of found objects in a single collaborative work. At the Tobin School in Cambridge, Massachusetts, where a year-long theme was Factories, kindergartners brought in whatever used items

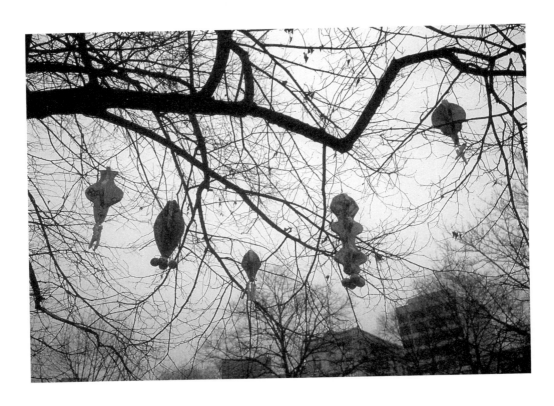

appealed to them—cereal boxes, hair rollers, clothespins, tin cans—and used these to create small architectural factories on cardboard cafeteria trays. With the help of two artists in residence, I built a giant dollhouse-like structure in modular parts that stacked six feet high: the fantasy factory where the cardboard trays lived. Working with their teachers, students drew in journals and dictated stories about their creations. It was quickly determined that our factory needed a library to house all the journals!

Think Fun

The experience of finding new and exciting ways to articulate concepts visually is a main reason I'm an artist. I love playing around, thinking up new ideas, making new things. It's the most natural human desire to want to invent and adorn, to want to break out of limitations and out of the box.

So be sure that "fun" is near the top of your list of key framing ideas. (This is

a prerequisite!) Have fun from the start, with your students right alongside you, when choosing a physical framework for your project. If you're using twenty-five deck umbrellas or two hundred recycled shoes, think of the most clever, engaging way to transform and display them. If you and your students decide to paint place mats, prosaic everyday objects, aim to make them the zaniest, most whimsical, or most provocative place mats on the planet. It's a truism: When an endeavor is fun, as well as educational, we're likely to learn our lessons well. In other words, fun isn't a frivolous notion; the thrill and *aha!* of thinking creatively, so central to any artistic endeavor, is also essential to education.

So far, I've talked about attitudinal frameworks and physical ones. Adopt these parameters at the start, and your likelihood of success exponentially increases.

I can hear readers asking: So just how do I get kids to actually work *together* on these things? Read on to learn about another kind of framework, the *collaborative* framework, and ways to make decisions and art together . . .

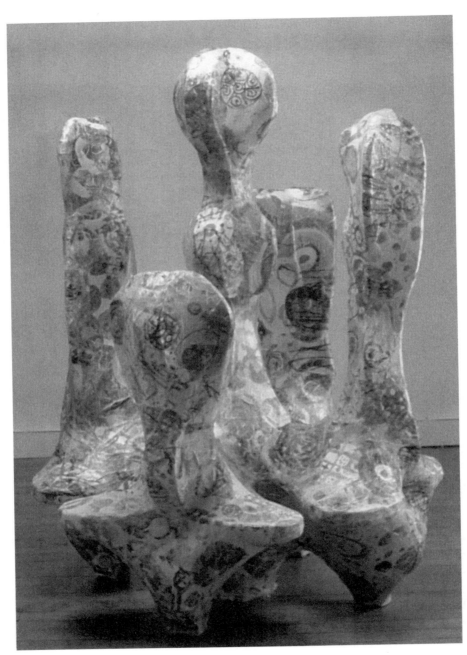

Open Circle social competency project, collaborative sculpture.

Chapter Four

Encouraging Collaboration among Kids

Collaboration is the heart and soul of my approach to art-making. The large scale, intense variety, and multilayered textures of the final products you see on these pages would, as a practical matter, not be possible without kids working together. Collaboration makes big dreams possible, and complex, beautiful results much more likely.

But without collaboration, something else hugely important would be lost too. Collaboration creates educational value all by itself. It requires skills in conversation, negotiation, problem-solving, and listening—lessons as essential as math and literacy. It models the kind of work adults do together in team-based projects all the time in workplaces, political associations, even families.

Your job, then, as master artist is to create a *process* as well as a final product. The process is one of spirited cooperation and conversation. "This process is all about people reacting with each other," says Olivia George, curator of the Snug Harbor Cultural Center on Staten Island, which sponsored one of my projects. "It's about what happens when children have to work *together* to make something happen. And it's about them becoming aware that they can help structure and shape the process itself."

Set out to give everyone a way to participate, have a voice, and feel a sense of ownership. These goals, while lofty and admirable, are easier said than done; I can guarantee that there will be times when it would be much more efficient, and perhaps effective, for you to make decisions on behalf of the group. Even so, I encourage you to involve and engage participants from start to finish, from the initial discussion to the preliminary sketching to the celebratory closing event. Why? Because students will feel a degree of pride and a sense of ownership that they likely wouldn't if *you* were to make most of the decisions.

Yes, collaboration takes time. And collaboration can be unruly; kids may disagree, they may have a hard time listening to different viewpoints, they may not

be able to come to a consensus as quickly as you'd like. Your classroom may be less controlled than usual—that's to be expected when one person doesn't have the final, or only, say. And it's worth it. As your students debate and vote on what to make and on how to make it, they're learning fundamental lessons about developing and trusting their own ideas, about how to rally as a group, and about the democratic process. They get to see that the most popular idea might not ultimately be the best for the project. They also learn that good ideas don't always win the majority vote. Kids aren't being lectured about getting along; they're learning exactly how to get along. Instead of a tedious homework assignment on democracy, this is democracy in action.

Dialogue and Decision-Making

Dialogue and decision-making happen throughout the art-making process. In fact, the bulk of the collaboration takes place well before the paints or crayons leave their boxes. *Anything*, really, can be the basis for discussion or put to a vote.

Artistic Framework: "What do we want to make? A sculpture? A collage? A giant mobile? A billboard? Do you have any other ideas?" When possible, give students a chance to choose the form, with one caveat: offer options that are doable. Show visual examples of forms from this book or others.

Project Theme: "What will our artwork be about?" Decide beforehand if the theme is wide open or if you want to set some parameters. For example, you can encourage kids to tie the theme in to a curriculum topic: "What are we studying that you'd like to turn into a fantastic art project?" Or you can present the curriculum theme—Egypt, immigration, algebra, conflict resolution—then invite kids to narrow the focus.

3-D Shape: "What shape should our sculpture assume? A number three? A starfish? A double helix?" Ask kids to work in collaborative teams to create miniature working models and present these to the class. Students then vote on the model they like the best.

Size: "Do we want this sculpture, mural, mobile, house to be two feet tall? five feet? fifteen feet?" You may need to set some parameters on this one: budget, time, and space considerations may require some upper bounds. Even so, you still can provide kids with ranges and choices.

Imagery: "Do we want to make one big image on our mural? Or do we want to paint an overall background and then make separate squares in which we can each express ourselves individually?" Ask students to work in collaborative teams to sketch ideas.

Color Palette: "Do we want to limit this to three colors? Five colors? Primary colors? Black and white?" Left to their own devices, kids tend to go crazy with color. The result can be glorious—or a muddy mess. Discuss limiting the palette to a family of colors to avoid muddiness: blues and greens, for instance, or reds and yellows.

Display/Installation: "Where do we want the artwork to live when we're done?" From the start, students will work with added seriousness of purpose if they know that their work will be seen by peers, parents, and others, and that they have some say in where it gets placed. Pride in public display can be quite a motivator.

Closing Ceremony: "What kind of ceremony do we want to have? Whom do we want to invite? Whom do we want to have speak? What should the invitations look like? Do we want food?" Kids love talking about this: a party, a celebration!

Don't panic! You can set time limits on discussion, and keep in mind that not *every* decision needs to be put to a vote. Kindergartners, for instance, needn't necessarily choose materials, or an administrator may have a strong opinion about where in the school to display the final artwork. Before you introduce the project to participants, whether they're your students or the entire school community, decide what is and isn't open for discussion. (One element that *isn't* up for grabs is that everyone will participate.) A rule of thumb: Allow participants enough substantial input so that they consider the project *theirs* and so that they get the chance to engage in the democratic process, a key feature of this approach.

Begin by introducing the project, the goal, and the participatory nature of the endeavor: "We're going to be working together to produce an amazing piece of art. Everyone will participate." If you've already lined up exhibition space, let kids know: "This will be exhibited on the major wall of the school." If not, let students know there will be an exciting brainstorming session about where to display the

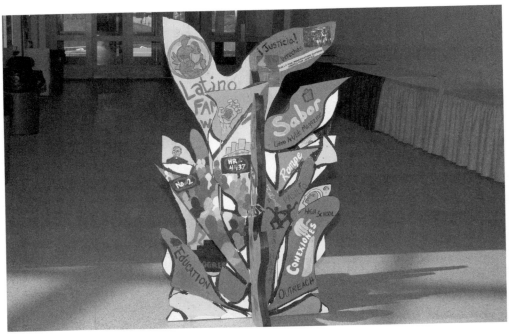

Boston College *Set the World on Fire* collaborative sculpture by the Latin Club.

final piece. Introduce examples of other projects, using this book, perhaps, to give kids an idea of the possibilities. Set a few ground rules: respect and listen, every voice counts, every idea's worth consideration, majority rules . . .

Let the dialogue begin!

Discussion, Voting, and Teachable Moments

Let's suppose that you and your students are sitting down for a planning conversation to choose the physical framework of the project. Facilitate discussion before the vote: "Why do you like this model for our sculpture?" If students are reluctant to speak, go around the room and ask each person to weigh in: "What do you think, Marissa? Your thoughts, Henry?" Here's one place where you need to take charge. Treat this like a brainstorming session and get as many ideas as possible out on the table; everyone needs to say something and say why. Document key points on newsprint—but not a whole pad! During one of my first projects, discussion rambled on for hours, resulting in sheet upon sheet of scrawling notes. By

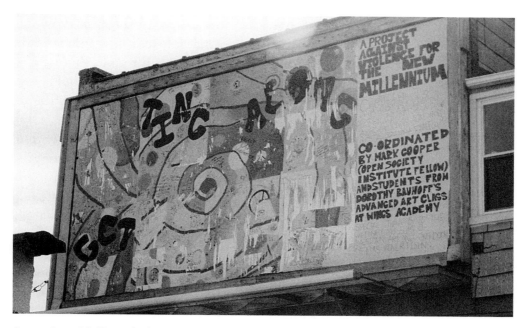

A weathered billboard, designed and executed by kids collaboratively. All elements of the design were the subject of discussion and debate.

late morning, before the pizzas arrived, the students were exhausted, their energies zapped by overextended conversation. Moral of the story: Discussions should be quick and efficient. Get kids voting and working, their hands in the paint, as quickly as you can. An important tip: If momentum is building for an idea that you see isn't workable in some way, step in and say so. Expert advice should inform any decision-making process.

Now on to the voting. This isn't a pretend election where a vote doesn't count; kids' decisions have immediate, direct effects on the project that they can clearly see and understand. Voting can be done through secret ballots or an open show of hands. Use a series of votes to narrow down a series of choices: "We can live with any of these four, but we're going down to two." Promote open discussion between each round of voting.

Sometimes a student may be disappointed that his or her idea isn't chosen. Don't downplay disappointment. Of course a child feels upset when his or her idea isn't picked! This is a key teachable moment, and your job is twofold: to

reassure students that there will be other opportunities to try out their ideas, and to help students appreciate the power and potential inherent in the democratic process itself. For example: "Even if your idea wasn't picked this time, the fact that *any idea* has been chosen means there's a place in the world for such ideas and that yours might get picked next time. The next round, things might be different. This is similar to a local or presidential election. Your choice for president may not get elected this year. But since there's a fair and democratic process in place, your candidate might win four years from now. What's key is that we agree to support the *democratic process* and go with it—regardless of what idea wins."

A smattering of students remain inconsolable, unconvinced? Reaffirm the value of collaboration: "We sure had a lot of wonderful ideas and I know you all wish your idea would've won. I encourage you to be *bigger than your disappointment* and to join in and help make the best artwork possible. Let's regroup and pull together as a team. Everyone's effort together is more powerful than any individual's. In our classroom, the spirit of collaboration is what is most important. Our art needs everyone's participation!" Also remind students that this won't be their last opportunity to create collaborative artwork. "We can always revisit this idea down the road. Maybe we'll make a second mural and use a second idea."

We live in a world rife with conflict. In a society and world so divided, we need to deliberately and continually reinvigorate the democratic spirit. It is imperative to start at home, in our schools, and teach kids peaceful ways to problem-solve, to exercise free speech, to allow for a range of opinions and come to agreement. The process outlined here isn't always simple, perhaps, but it is vital—and teaches lessons that resonate far outside the classroom.

An Example: Inspired by the Ocean

Salem, Massachusetts, is surrounded on three sides by the sea. The Bates Elementary School was about to move to a new location in town, a new building whose architecture referenced ship design in a wonderfully playful way. The principal recruited me to help create a huge hanging sculpture for their atrium which would thematically tie in to the study of the sea that so defines Salem's identity as a community. Along with the teacher in charge, I systematically met with every class in the school, gave a short presentation on the ocean, and displayed books featuring drawings and photographs of aquatic life. The teachers and I then divided students

The winning design, in cardboard, from among several proposals by teams of students at the Bates Elementary School for a sculpture depicting ocean themes. Decided by voting process. The final work is pictured in chapter 3.

into small groups and asked them to conceive and create models of miniature three-dimensional sculptures, using just construction paper and tape.

After the models were done, students discussed and debated their merits and voted for the top class design—a kind of primary election. We then collected all of the individual class nominations and held a schoolwide election for the final model (which I subsequently turned into a full-blown sculpture). The winning seaweedlike form came from a team of kids that included a very sweet boy who had been having major trouble paying attention in school. There was a poetic beauty to this team's triumph that had a clear impact on this boy's self-esteem; he was beaming, and I could see delight in the faces of his classmates, too, who had been quietly watching his struggles over time. Everybody was happy for him, me included.

Collaborative Mini-Assignments

Once basic decisions (about artistic theme, framework, shape, and size) have been made, it's time to dive into the making of art. Consider warming up with some collaborative mini-assignments. Similar to writing prompts in English class, drawing and painting prompts can come from you or from your students. Try making a game out of any of these:

❋ Working in groups of three, make a hundred lines on your page in any direction you want. Follow these rules: use red, yellow, and blue to paint short lines, no more than an inch in length, with red always coming first, yellow second, and blue third. Then repeat on a new page, this time with no restriction on the order of colors. Take turns and watch as the pages fill with color and patterns. Talk with each other quietly about what you see.

❋ Start with your own piece of paper. Make eight dots and pass the page to the next person. Connect the dots and pass the page to a third person. Create a painting using the connected dots as a starting place.

❋ Draw an outline of a human body, and paint different patterns inside. For example, fill arms and hands with polka dots. Draw striped legs and feet. Draw a tiny face with a crazy zigzag hat. Cut out the different body parts and trade some with your neighbors, mixing their parts with yours. See how colors work together. See how patterns work together.

✳ Ask pairs of students to come up with mini-assignments of their own and to write these down on slips of paper. Put the papers in a jar and pull assignments out at random to spark new ideas.

Collage: The Basis of Collaboration

Collage, the assemblage of different parts into a single, unified whole, is the basis of most of the collaborative work I do with kids. Collage lends itself especially well to collaboration since by definition it involves the visual coming-together of disparate things—disparate styles, textures, images, strands of art and cultural history, and so on. Imagined broadly, collage mirrors contemporary society, people from different ethnic groups, with different religions, belief systems, habits, and cuisines who come together to form cohesive communities. Each one of us might be seen as an individual living and walking collage sculpture, pieced together from ancestors with different personalities, from different parts of the world. As a riff on the melting-pot metaphor, I like to think of America as a collage in progress, an evolving work of art. But metaphorical associations aside, collage is a practical and easy way for young artists to make impressive, large-scale artwork.

Here's how the process works. Individually, in pairs, or in teams, students create discrete paintings that they then apply to one common form (the billboard, mural, sculpture, mobile, or whatever you've chosen). As I've mentioned before, the drawings needn't be sophisticated. If one of your students happens to be a skilled calligrapher, fantastic; but a high degree of skill isn't required. If you happen to run into a resistant "I-don't-know-how-to-draw" student, ask him or her to do something simple and achievable, akin to one of the mini-assignments: "Paint this background red. And why don't you add three polka dots of different sizes, put a smaller dot inside of each dot, and then connect the dots." Before a student knows it, without any predetermination, he or she has created something visually quite complex.

In the Bates Elementary School project, we took another schoolwide vote to decide what kind of imagery to paint for the surface of the giant seaweed sculpture. Kids chose the unusual patterns on fish and other aquatic life. From this point on, no one worked alone. In each classroom, one student started a painting then passed it along to another and then another. By the time these painted

images—each one a collaborative work in itself—got collaged onto the sculpture, everyone felt a rock-solid sense of collective ownership.

Once your students finish their drawings, whether solo or team creations, it's time to collage these onto the form. If drawings were done on paper, students brush the back with clear acrylic polymer, a high-quality Elmer's glue, and stick them on the form. If done on fabric, students dip the whole piece of fabric into the polymer. Someone needs to decide, you or the group, whether students will apply their own paintings or someone else's to the form. You also need to decide who goes first. You might choose kids at random. You might have kids draw straws. You might select the first student who is done and ready. You might ask: "Who feels inspired to go next, based on what you see?" Invite students into the conversation; this is part of the creative process.

Next, guide students with a series of questions to get them thinking about placement. For example: How do you want to take the viewer's eye around the artwork? What colors look good next to each other? Do you want to create a checkerboard? Do we need some variation in this area? Does this spot need more red? Do you want a blue section to merge into a green section?

Inevitably, some paintings will be more visible than others. This is another time to remind students that everyone's contribution, even if it's tucked in a corner almost out of sight, is important. It's the collaborative effort that matters. The choice is about the whole, not the parts. How can my part support the whole? Inform students that it's *noble* to be in a quiet, less prominent, place: "You may have to give up a little ego, but you're doing so for the good of the artwork, you're sharing the glory." With your students, reflect on the quiet, less prominent contributions that people make every day—in every aspect of life—that are oh-so-necessary, but that too often go unnoticed and unapplauded. Rarely is humility praised in education. Here's a chance to laud it in a tangible way.

Revel and Reflect

Opportunities to learn and collaborate by no means end when the paint or glue dries. After the flurry of construction, take a step back, revel, and reflect with your students. "Wow, look what we did!" The process of reflecting as a group solidifies the achievement for participants and makes it easier for them to apply the experience to other events in their lives. In other words, meaning-making helps to en-

sure that the students' collaborative experience lives well *beyond* the collaboration. Sample reflection questions:

❋ What do you think of your creation? What does it make you feel? What does it remind you of? What kind of questions does it bring up?

❋ What does your artwork have to say about the themes we are exploring? What are some things the artwork has taught you?

❋ Who would you like to see your artwork? What do you hope people will see in it? What do you hope it will make them feel?

❋ Does it matter to you that you worked together on this? Do you think it will matter to the people who see this?

❋ If we had this to do all over again, what would you change about the process?

❋ What did you learn about making decisions together? Do you think collaboration is worth it?

❋ Is the final work what you imagined it would be like when we started? How is it different?

Of course all of these questions can be turned into writing assignments that bring art—and the powerful experience students have just been through—right into the middle of any school's literacy curriculum.

Hundreds of Participants

What if you're ambitious and want to involve an entire grade, school, or town in a collaborative art project? How do you get fifty or seventy-five or three hundred kids (or adults)—whom perhaps you don't know very well, who may speak different languages, who are different ages, and who have vastly differing artistic abilities—to work together respectfully, efficiently, and enthusiastically on a large-scale work of art that has lasting significance?

Dream big.

I had such an opportunity at the Driscoll School in Brookline, Massachusetts, where the entire school got involved in a project called Facing the Millennium. Teachers and administrators decided to transform a fifty-foot-long outdoor wall

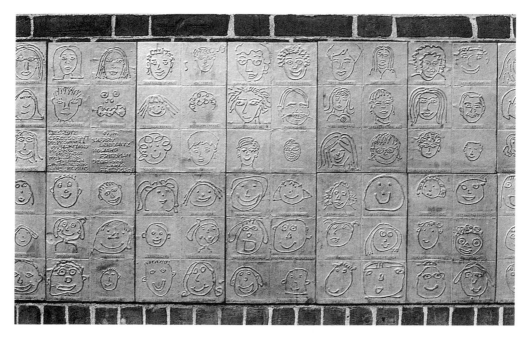

Bronze tiles at the Driscoll School, Brookline, Massachusetts, called *Facing the Millennium*. Everyone in the school-young and old-did a self-portrait. A school improvement and renovation project turned into large-scale collaborative art. The wall was 50 feet long and 2 feet high.

with tiled bronze portraits. Everyone in the school—every student, teacher, staff member, custodian, bus driver—drew a simple portrait of his or her own face on a small piece of paper with a squirt bottle filled with modeling paste. A new spin on cake decorating! I took all of the individual drawings to a foundry that inexpensively cast them into bronze tiles, each one composed of six small faces. When the wall was put together, made up of several hundred of these tiles, that's when the collaboration became evident.

There's something worth noting here. The sheer scale of this project meant that not everyone could be in the same room at the same time and that not every aspect of the project could be subject to collaborative decision-making. A general rule may even apply: The more people involved, the more guidelines *you* may have to determine before collaborative work begins. What you may lose in terms of the power of collective decision-making, you gain back in the scale and impact of the

Collaborative sculpture, displayed at the Whitney Museum at Phillip Morris.

artwork—and through the thrill of drawing together an entire community, not just a small subset.

I helped to orchestrate another communitywide project in New York City, spanning two full years and involving hundreds of students at all grade levels (K-12) in schools in all five boroughs. Students at each school worked on their own particular segment of a sculpture designed to fuse with the others into one huge collaborative piece. The first time we all laid eyes on the final work of art was at the closing ceremony at the Whitney Museum sculpture space at Phillip Morris.

The Whitney staff and I took a deep breath and chose to view the closing ceremony—which brought together a horde of rambunctious kids—as a collaborative *opportunity* and not as a recipe for chaos. We put together five stations—including a sculpture-naming station, a refreshment station, a collaborative billboard-building station—through which kids could rotate in smaller groups and work on specific projects. To save on time and cut down on messiness, I approached a high-school class in the Bronx to make the background image for the collaborative billboard. The students discussed and nominated ideas and eventually elected to paint a series of pastel elliptical circles. At the billboard station at the Whitney, kids drew with permanent child-safe markers on this background, spread out across the floor; at another station, they created small sculptures with recycled materials; while at another they discussed their collaborative sculpture, brainstormed titles, and logged these into an exhibition journal.

Don't be daunted by the prospect of working with a very large group. As these examples make clear, not everyone has to discuss, vote, paint, or collage in the same space. Working toward a common end, participants can have distinct jobs at distinct locations, whether it's upstairs in a different room or across town in a different school. Your role remains the same—master artist and master coordinator. In this instance, however, you're conducting not a chamber group but a major symphony orchestra.

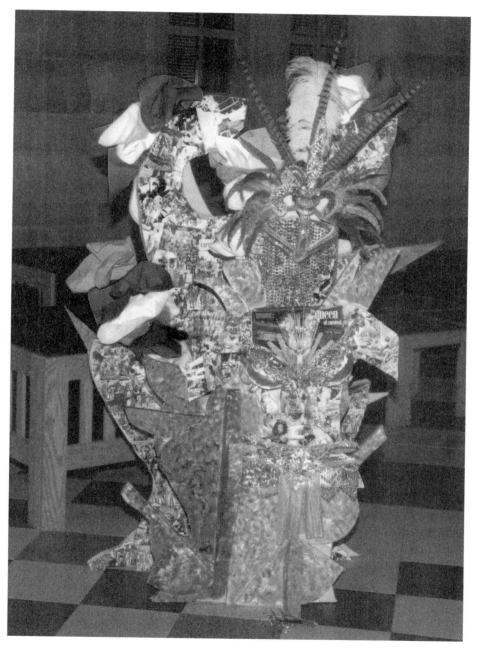

Boston College, Set the World on Fire, collaborative sculpture by the Caribbean Club.

Mark Cooper, paper installation, 2006.

Chapter Five

The Perspective of Contemporary Art

Psychologist and Harvard educator Howard Gardner brought attention to the multiple ways that people can be intelligent: some of us are intelligent mathematically, others interpersonally, others kinesthetically, and still others spatially, musically, emotionally, and so on. Everyone exhibits all of these intelligences in varying degrees; we are all different combinations of different ways of being smart.

The same holds true for art-makers. Some people are wonderful realists, some have an amazing eye for color or for geometry, while others create fantastical cartoons, collage, or sculptural forms. There is no *one way* to be an intelligent artist, and contemporary art recognizes this.

I recently spent an afternoon walking around Lower Manhattan, visiting a dozen of the more than six hundred art galleries in New York City. On Twenty-fifth Street I walked into a gallery that looked like someone had taken apart a whole house and reinstalled it in a single room. Interspersed among the couches, chairs, beds, mirrors, and lamps, TV screens displayed dissonant images of desert cacti and couples walking on a beach. One block south, on Twenty-fourth Street, I walked into a gallery featuring two movie-theater-size screens with giant elephants swaggering across them. Next door, I viewed tight realist paintings of water towers and Manhattan rooftops. And on it went. By the end of the afternoon, I'd seen an out-and-out smorgasbord of art being exhibited *and* accepted as valid.

This hasn't always been the case. When I was a kid in school, the students who could draw a flower that looked like a flower were identified and tracked as the artists. No one else counted. This attitude had been handed down for centuries in the Western artistic tradition. Stemming from Greece and Rome and spanning centuries of European representational art, there has been a worship of artistic *rendering skill;* only someone who could paint in oils or sculpt something realistic was hailed as a legit artist. Even as modernism took hold in the twentieth century and there was much ado about "art for art's sake," dominant styles still dictated

Mark Cooper, Mask, watercolor on paper.

Mark Cooper, from the series Still Standing, oil on canvas.

Mark Cooper, from the series 32 Hours, mixed media.

what was viewed as interesting and acceptable and worthy art. For a time, abstract expressionism was in vogue; if you were a realist in 1965 nobody would give you the time of day. Later, minimalism and Pop Art were the rage, followed soon after by neo-expressionism. Until the dominance of postmodernism near the end of the twentieth century—in which it became the norm rather than the exception to layer style upon style in a single piece of art or on the same city block—the mainstream art world continued to trade one prevailing orthodoxy for another.

No longer. We now live in a golden age of artistic diversity. Art is no longer exclusively about drawing a face that looks like a face *or* about splattering paint in an expressive way. Art is about communication, and contemporary art celebrates the innumerable ways to make a statement: realism and structured order, abstraction, collage, performance, traditional figuration, random occurrences, cartooning, popular culture appropriations, sound effects, and on and on.

The very ideas and techniques that allow contemporary art to diversify and break down old boundaries can allow kids to tap deep sources of creativity and create great things.

Open Students' Eyes

Before you begin the actual art-making process, aim to blow kids' minds with what's possible, what constitutes art, and all of the different approaches they might take. Show them tons of examples for inspiration, and show them real art if you can.

Mark Cooper, detail from 32 Hours.

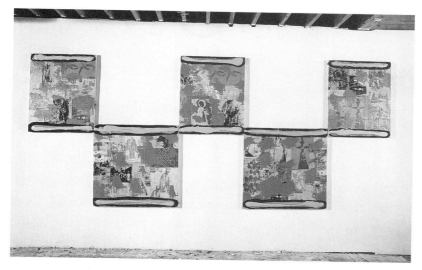

Mark Cooper, Still Standing.

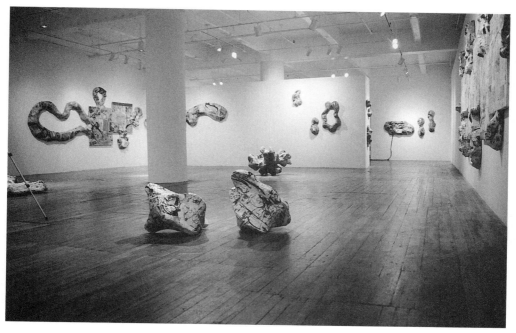

Mark Cooper, installation, 32 Hours.

Line up a trip to a museum, one that houses modern art. Look at books, view videos, go to the library, or go online, and get inspired. Encourage students to look at art as artists themselves: "How do other artists, like all of you, use color, frame pictures, present ideas?" Encourage students to view every work of art as a vocabulary that they themselves can borrow from, build on, or react to. It pays to familiarize your students with these many new art-making ideologies and approaches because they, like many of us, may have swallowed the antiquated view that you're only an artist if you know how to draw in a realistic, Renaissance manner.

Consider starting or ending each school day by viewing a piece of art in a book or a PowerPoint presentation. Keep in mind that it may be counterproductive to teach about an artist's life and history; you want to avoid hero worship at all costs. (It's crucial to be inspired, but equally crucial not to be paralyzed by the fact that you are not Picasso.) Instead, allow your students the simple enjoyment of *looking* at the artwork. Pose questions to get students noticing and thinking for themselves *as artists*. For example, if you're looking at a painting by Miró, you might ask: How many different colors are in this painting? How many simple line drawings can you find? Where are solid, big blocks of color? How many times does blue touch green? Are there any empty spaces? Which areas are most crowded? Is there anything funny here? What does this make you think about? Does it remind you of anything you've seen at school, in your house, or in your neighborhood? Is there anything you can learn from this that you could put in your own paintings, and express in your own way? You don't have to have a Ph.D. in art history to help your students scrutinize a work of art. Play and have fun with this. And remember: You're helping your students develop critical thinking skills along with their visual intelligence.

From Duchamp's Toilet to Christo's Gates: The Power of Concept and Context

All of these collaborative art projects pay homage to Marcel Duchamp, one of the first artists to teach the world that anything goes artistically *if* it's placed in a context that causes viewers to see in a new way. In the early part of the twentieth century, Duchamp took ordinary, ready-made objects—a toilet, a coat rack—and installed these in art galleries. The fact that Duchamp, the artist, had had no hand in the actual creation of the toilet did not matter. The mere placement of the toilet in the gallery automatically destabilized its common meaning. But one more ele-

Mark Cooper, Spin Doctors Recreated, collage.

ment was needed to transform the toilet into art: a willing viewer. The moment the viewer questioned his or her preconceptions and expectations—*voilà!*—the artistic "transaction" was clinched.

Fast-forward to the turn of the twenty-first century. The contemporary German artist Wolfgang Laib creates amazingly beautiful installations out of—believe it or not—pollen. From early spring through September, Laib painstakingly collects pollen from flowers and plants and then pours it in patterns on the floor of public spaces. Through hours of experimentation, he has refined the technique of pollen extraction and knows the differences among the textures and weights of hazelnut pollen, pine pollen, and dandelion pollen. The results are remarkable: shimmering, luminous, almost magical reminders of the invisible aspects of nature around us, our debt to nature, our distance from nature. Instead of replicating a flower in pen and ink on paper, or in oil on canvas, Laib extracts the very essence of a flower and hands it back to us as art. I find it interesting that Laib's art, while beautiful and thought-provoking, is in no way shocking to the art community. Duchamp opened the door, and here we are, some seventy-five years later, where anything goes: an innovative work like Laib's or like yours.

In 2005 the artist Christo made headlines when he and his wife, Jeanne-Claude, created an installation in New York City titled *The Gates*. (They are also known for draping islands and mammoth buildings in sheeting.) With the blessing of the mayor and the help of hundreds of volunteers, they erected more than seventy-five hundred identical orange-draped gates across more than twenty miles of footpaths in Central Park. Each gate taken individually was nothing remarkable. The art was in the visionary scale and ambition of the piece, as well as in the collaboration necessary to execute such a huge spectacle. The artwork was designed to be temporary, not for the ages but for the patrons who would stride through it. Thousands of people will never see Central Park the same way again.

How do these examples apply to your projects? Like these artists, your students can use a huge variety of materials and techniques. Found objects of any kind can be incorporated into their fine art. While your kids probably won't choose a toilet for their artistic framework (never say never!), by installing their artwork in an unexpected context—in particular, by grouping them together in large, thoughtful arrays—you oblige viewers to pause, think critically, and view something that might appear commonplace (for example, children's drawings that they've seen

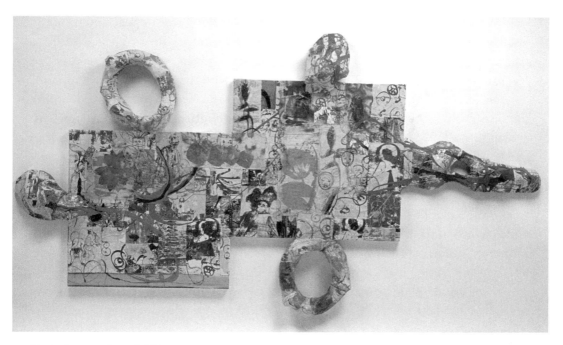

Mark Cooper, from 32 Hours.

a million times before and *assumed* they understood) in a striking new way. Ten different masks, clustered together, similar to ten different versions of Marilyn Monroe in an Andy Warhol diptych, are bound to open some eyes. Similarly, when your students make a collage, the individual drawings take on new layers of meaning when one overlaps another and another and another. Suddenly we see and say: "Wow! I never thought about it this way before." "More flair and variety than I ever thought possible from this group of kids." "What a diversity of viewpoints. I see my community in a new light."

Whether your students paint simple self-portraits or tie their artwork to broader subject matter, their creations, like those of the fine artists I've described, emerge out of *concepts and ideas.* At the risk of committing blasphemy, I want to emphasize that these projects are not primarily about developing children's artistic skills, at least not as typically taught in school. Most art curricula lead kids in a step-by-step manner through a series of lessons about complementary colors,

shading, perspective, brush-stroke techniques, sculpting techniques, and so forth. Each of these lessons is important; don't pass up the chance to teach skills as part of these projects if that's your interest or your educational mandate. You can tell students, "Paint a yellow line and outline it with a complementary color" or "Shade this area from dark to light." Understand, however, that the key learning lies in the play of *ideas*—thematic, visual, historical. These projects develop critical-thinking skills: how to conceptualize a project and articulate a set of ideas. In short, how to think (rather than draw) like an artist.

Finally, like so many fascinating works of contemporary art, your collaborative project casts the talented individual *out* of the limelight. Attention shifts instead to communities of collaborators (even bees!), to the artwork's commentary on the wider world, and to viewers' personal experience of the work, that magical *aha!* moment. All of these elements make both your students' art and Christo's *Gates* tick.

What children do together in the whole *process* of collaborative art-making parallels what adult artists do in the real world in very rich ways. Kids really are "doing art," in all its complexity, tracing all the steps adult artists would trace from concept to completion. The scale and ambition allowed by collaboration allows kids to think—for extended periods—like real artists.

My Own Work

I am a working, exhibiting, contemporary artist. My personal artwork (not the collaborations I do with kids) is a synthesis of many of the ideas I present in these pages. For instance, I've been fascinated for years by how meaning changes through context. In my collage work, I might take a fragment of an image from an ancient Persian miniature, change its scale, alter its color, and then juxtapose it with a fragment of a well-known Greek sculpture, underneath a fragment of a Rembrandt drawing which I've distressed or made monochrome, and the meaning of each individual piece radically changes. Even when working all alone in my studio, in a way I'm working in collaboration. I appropriate freely, playing with images and materials from around the world and combining them in ways that explore complex connections. In the process, I'm in endless conversation with the original designers: artists who've lived throughout history.

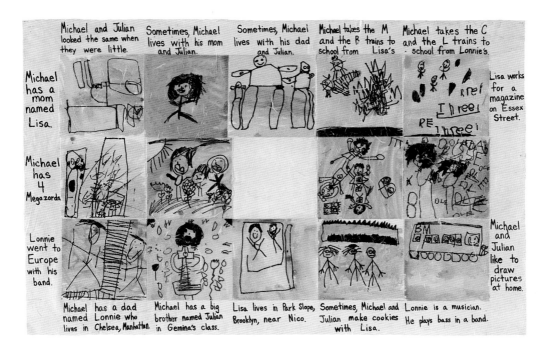

Collaborative family portraits, both 40"x 60," from the kindergarten class of David Harris. The entire class worked on panels for each child's family.

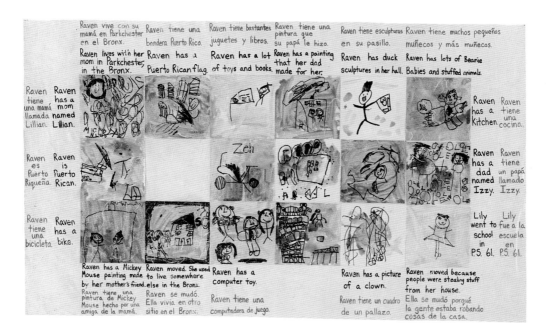

Student-made backlit diorama in subway station, Washington, D.C. (*top*, 40"x 60"x 5"), and billboard (*bottom*, 126"x 300").

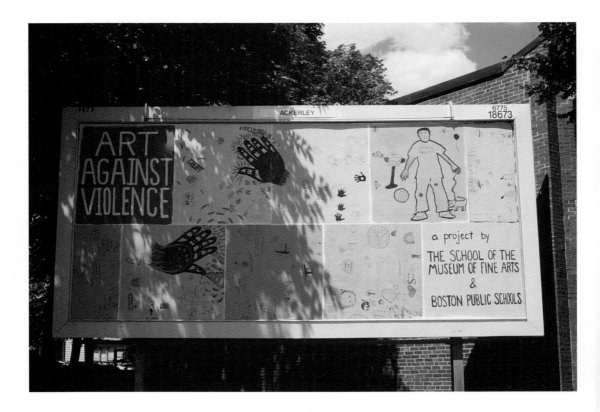

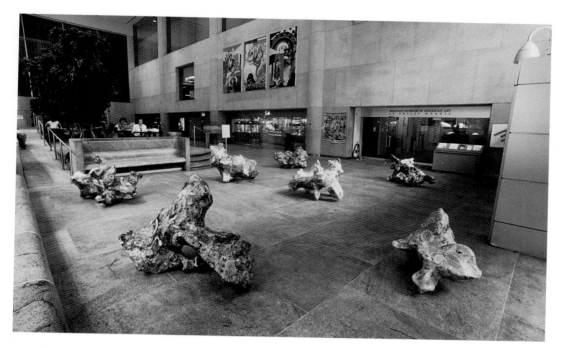

(*Top*) Getting Along Project Against Violence, an installation at the Whitney Museum of American Art at Phillip Morris. Each piece approximately 48"x 48"x 48." (*Bottom*) Masks, displayed in Museum of Fine Arts Boston. From a collaborative project with the Boston Children's Museum and the Boston Public Schools, 48"x 36."

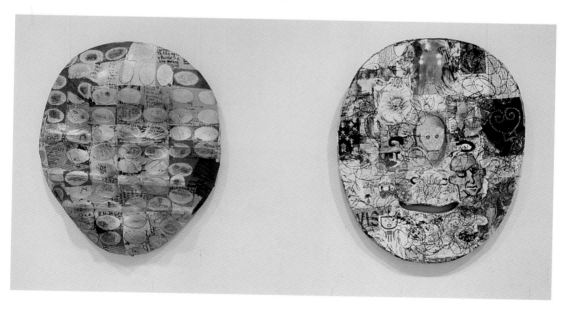

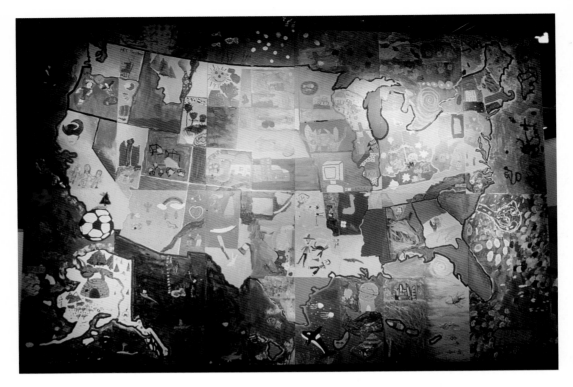

U.S. Map, 192" x 420," made by forty-nine children in a program with the International Child Art Foundation.

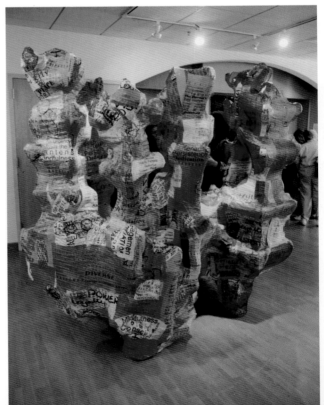

Words on Fire, a collaborative piece about censorship, 78" x 84" x 48."

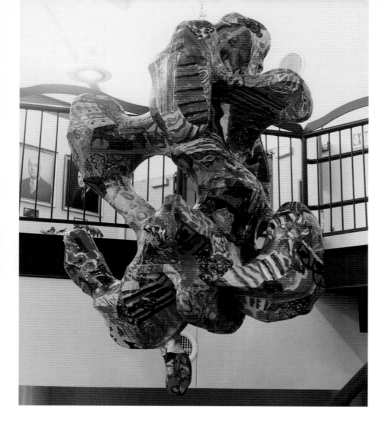

Large hanging sculpture on marine themes, designed and painted by kids, Bates School, Salem, MA, 72" x 54" x 48."

Interlocking puzzle pieces, Boys and Girls Clubs of Boston, 66" x 48" x 48."

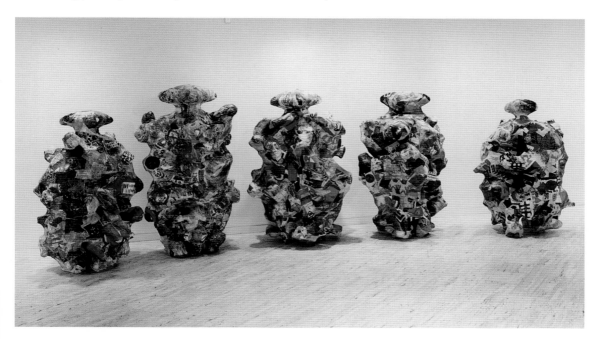

Mark Cooper, from the series 32 Hours, 120" x 84" x 5." Mark Cooper, collage, 36" x 24."

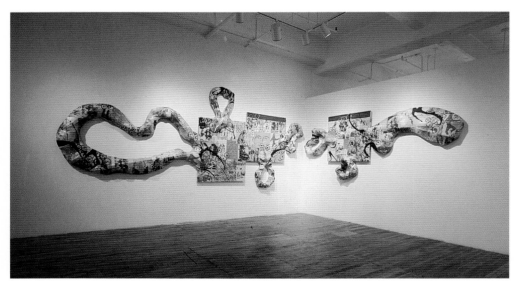

Mark Cooper, installation, 32 Hours, 120" x 360" x 5."

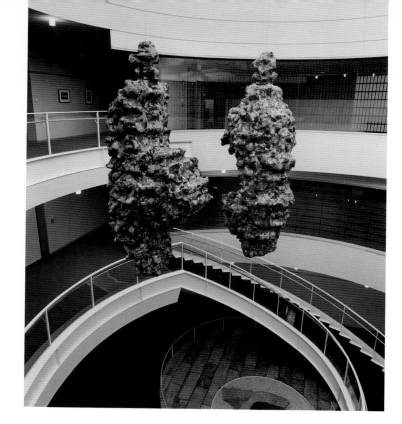

Mark Cooper, Virus and Cure, 240" x 84" x 252."

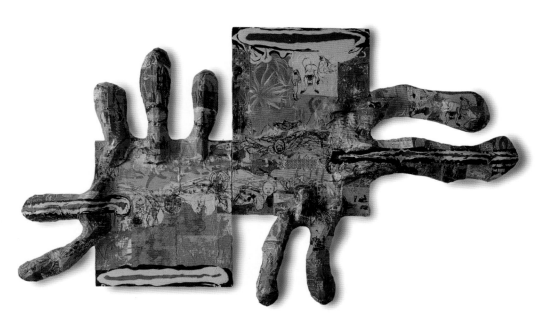

Mark Cooper, Still Standing 2006, 84" x 120" x 5."

Mark Cooper, collage, 84" x 84."

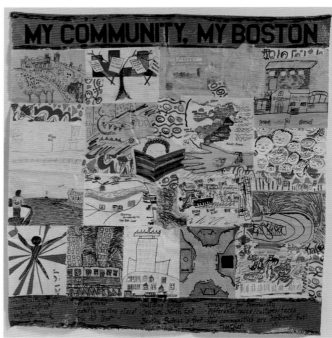

Collaborative collage made by
librarians in Boston public libraries,
48" x 48."

What does my art have to say? Why is it important? It's my reflection of the world I live in, my experience of urban life: fast-paced, digital, media-driven, information-dense, dislocating and connected at once. Turn on the nightly news, you're bombarded with random imagery. Drive through any city in America, you experience one visual interruption after another. Collage for me is a perfect medium with which to explore contemporary life, not only the clashing of images, ideas, religions, and cultures, but also one of my own chief obsessions as an artist: our interrelatedness in this global community.

My work with large groups of collaborators is an obvious extension of my individual work. Compare a work that I created in my studio with a collage made in collaboration with librarians from the twenty-five branches of the Boston Public Library, and you'll notice some clear resemblances: the shape and dimensions of the grid, the stripes of color at the top and bottom, the juxtaposition of images from diverse sources, the complexity and density of detail. There are also some striking differences. While my collaborators from the ancient world don't have a voice in how things get done, at the BPL the collaborators were living, breathing human beings who made all the artistic decisions—from framework to palette to images—themselves. The resulting difference is big, chiefly due to the different sources of images. My work bears the identity of an individual; the other reflects the imagination and multiple intelligences of a community, as will yours.

Mark Cooper, Jacks Are Wild, collage. The differences and similarities between this work and the collaborative collage on the next page are worth exploring.

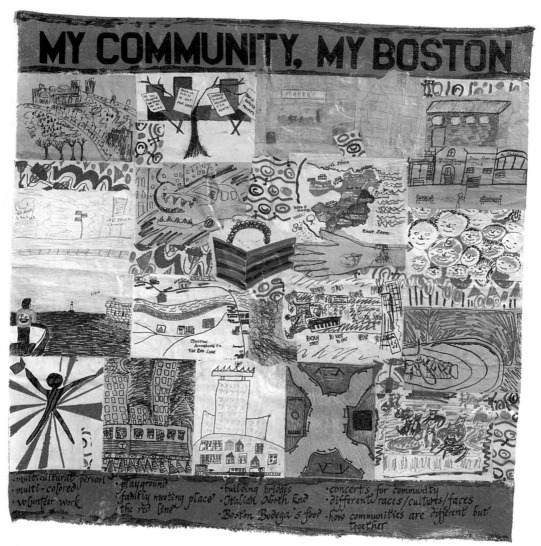

Collaborative collage made by librarians in city of Boston branch public libraries.

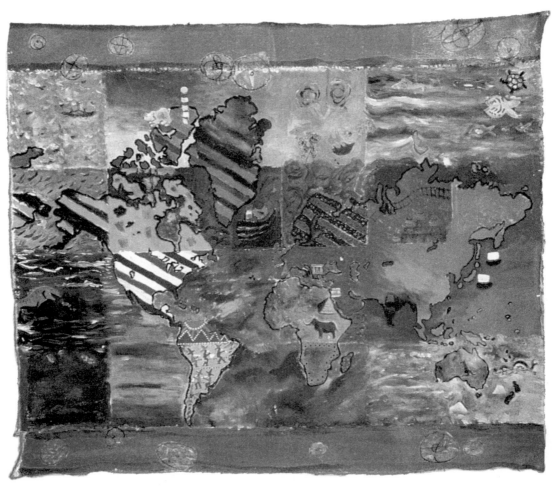

World map collaboration, Snug Harbor Cultural Center.

Chapter Six

Words on Fire: Tying Art to the Larger World

Too often art is one of the first things to be cut from school budgets because, critics argue, it isn't relevant to serious learning. But art shouldn't be something kids do only in art class, or as an extracurricular activity, or to make a pretty picture. While there's nothing wrong with pretty pictures, art can be much more than that.

Done seriously, art-making can serve as a powerful entry point into every subject at every grade level—science, math, history, literature, bullying prevention, current events—allowing students to get a visual and tactile handle on abstract ideas. Far from supplementary, collaborative art-making can play a central role in your curriculum, whether or not you see yourself as an arts teacher. First-graders make a mixed-media collage using crayons, rocks, shells, bottle caps, and string, and in the process they hone fine-motor skills and sorting and grouping acumen. Sixth-graders conclude a unit on architecture by building their own skyscraper, re-inforcing lessons in measurement, scale, and proportion. Eleventh-graders create a 6 ft. x 6 ft. sculptural molecule to finish a science unit on genetics and gain a more intricate understanding of the building blocks of life. Immerse students in a large-scale collaborative project in any area of study and I guarantee they'll remember more information a year from now than they will if you rely only on textbooks, tests, on-line resources, or even a trip to a museum.

Over the years, I have worked with scores of teachers who have linked collaborative art to the larger world—in particular, to immediate curricular goals—with remarkable success. They achieve this in several distinct ways.

First, the skills used in making art are often the same skills teachers are charged with developing in young students: fine-motor control, learning how to count and sort, and distinguishing among colors and shapes.

Second, the artwork can be the medium through which students explore another domain, from history to geometry to social science to science. From David Harris's exploration of family to the Bates School's maritime explorations, art-

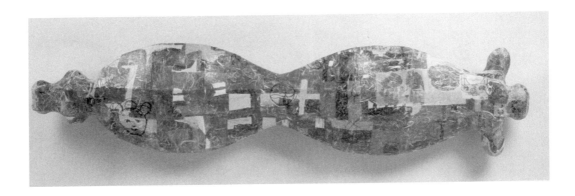

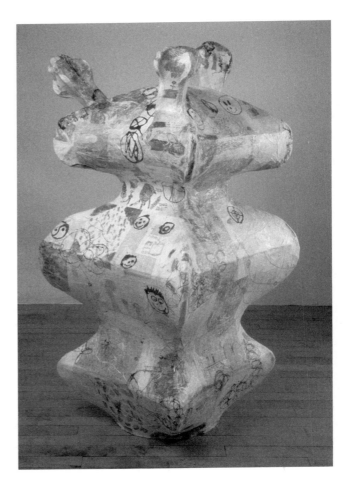

Collaborative sculptures from
Getting Along project in New
York City.

making is a lively and effective means of exploring the world outside the class-room.

Third, the open-ended frameworks invariably inspire student ingenuity and creativity.

Fourth, the link to contemporary art demands that students think both contextually and conceptually.

Fifth, in order to take their work public, students have to practice the arts of diplomacy and public speaking.

Finally, the creation of the projects can be a living laboratory in democratic process and cooperation, a civics lesson with a memorable and enduring product.

I devote the rest of this chapter to showing you examples of how I and some talented teachers have linked collaborative art to a range of topics—curricular, political, social—in creative ways. (You've seen a few of these projects earlier in the book; the emphasis here is on how they forge connections with broader topics.) Feel free to duplicate or adapt these ideas to make art relevant to any subject at hand.

Art and the Curriculum

WHITNEY MUSEUM PROJECT, NEW YORK, NEW YORK
TOPIC: GETTING ALONG

This project spanned two years and involved approximately five hundred students from ten lower, middle, and high schools and one homeless shelter located across all five boroughs of New York City. At the start, kids took a tour of the Whitney collection with museum educators and viewed selected artwork relating to significant invention, thought, and historical moments in the twentieth century: everything from changes in immigration patterns to the building of the Brooklyn Bridge to the first TV. Students learned that artists were actually *saying something* with their art, and that they could do the same. The project culminated in four billboards and two different exhibitions at the Whitney Museum's space at Phillip Morris. The art was later permanently installed in each participating school.

The overall theme was Getting Along, and kids from the five boroughs worked together to contribute imagery to the billboards and sculptures. There can be great psychological distance among people living in the Bronx, Manhattan, and Queens!

Wherever you live, whoever the "other" is—people on the east side of town, the north side of town, the town across the river, the city twenty miles down the road—all of them are potential collaborators on an art project. The kids' artwork connects them to world events; the process of making the artwork connects the kids themselves.

Of course, "otherness" can beleaguer students in a single classroom: the quiet girl, the overweight boy, the student who practices a different religion, the non-athlete, the geek, the bookworm. When you make collaborative art, you're not just *saying* Love thy neighbor, you're working together with your neighbor, perhaps a former stranger, to produce something fascinating and original you couldn't possibly make on your own. The resulting art attests to connections made.

SOLOMON SCHECHTER SCHOOL HOLOCAUST PROJECT, STOUGHTON, MASSACHUSETTS
TOPIC: HOPE AFTER THE HOLOCAUST

Hope after the Holocaust, a yearlong, schoolwide project undertaken at a private Jewish school, focused on the enduring human spirit. Students not only studied World War II, they also extended the project beyond classroom walls by interviewing and exchanging letters with Holocaust survivors, a life-changing experience for many. Students painted imagery and collaged their paintings onto a two-part sculpture that remains in the school as a permanent installation, ongoing teaching tool, and legacy for future students.

SCHOOLYARD PROJECT, BOSTON, MASSACHUSETTS
TOPIC: MULTIDISCIPLINARY

The Boston Schoolyard Initiative recently hired me to transform thousands of acres of ugly asphalt schoolyards into colorful outdoor classrooms that could tie into games and curricula being taught in schools. I began with two schoolyards in a pilot project.

I decided to polka-dot the playgrounds with abstract clusters of circles—three here, two there, five over there—as well as organized arrangements (for example, twelve circles in a half circle, each a child's arm's length away from another, so that kindergartners can sit in a semicircle and tell stories). Some circles include words and questions—for instance, "What do you dream about?"—to serve as

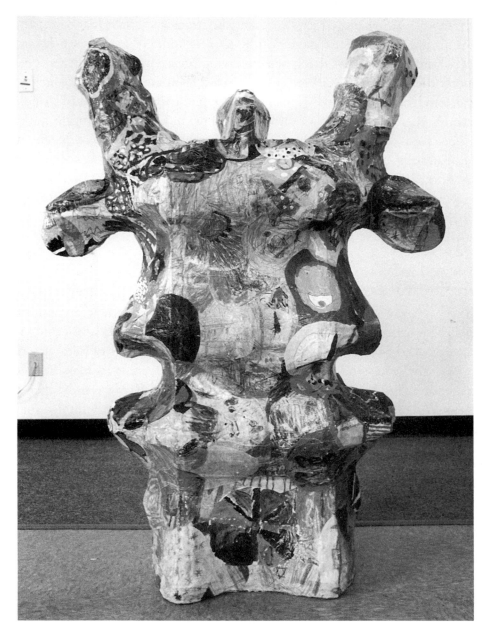

Sculpture from larger investigation into history of the Holocaust and the possibility of hope, at the Solomon Schechter School.

prompts for writing projects. Others are variations of ornate mandala patterns with numbers and letters hidden within. Others contain images of birds, monkeys, pyramids, and other living and nonliving phenomena that can serve as the basis for storytelling. "What kind of bird is this?" you might ask, and you're done; or the conversation may take you suddenly into the depths of a South American rain forest.

View your school playground as a blank canvas. If given the chance, what would you paint on this? A series of walkways? A grid of a hundred circles? A herd of giraffes? Any teacher can create drawings or text with students in a classroom, go to Kinko's, copy them to a digital file, and send it to a graphics company that can transfer the images onto circular stickers. To ensure that kids don't inadvertently tear the stickers off the asphalt, I glue the circles down with clear epoxy.

TOBIN SCHOOL PROJECT, CAMBRIDGE, MASSACHUSETTS
TOPIC: FACTORIES

To tie in with the study of factories, kindergartners created an architectural structure, an abstraction of a factory. Kindergartners and their families collected found materials: cereal boxes, pipe cleaners, tongue depressors, pieces of foil. Each child then used the hodgepodge of seemingly unrelated materials to make free-form machines and the inner workings of a factory; the results were then placed on cardboard cafeteria trays. I built a factory complex out of wood in simple modular units that could be taken apart and rebuilt from week to week. Kids' imaginations were in high gear. The students placed their tray creations on different factory floors, and then drew pictures that they collaged onto the factory.

To adapt this project for older students, simply raise the bar. For instance, they can use more advanced math to design the structure, and they can research the history of the labor movement, the industrial revolution, the more recent technological movements, and so forth.

BIRCH MEADOW SCHOOL PROJECT, READING, MASSACHUSETTS
TOPIC: MULTIDISCIPLINARY OUTDOOR CLASSROOM

Space is at a premium in schools, so finding a home for a permanent installation can pose a challenge. Since there's often more unused space outside than in, consider creating an outdoor sculpture. If you think about the campuses of many

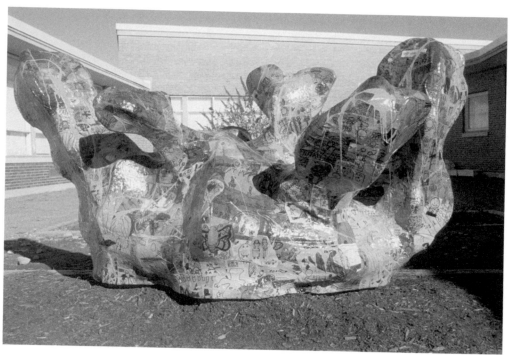
Birch Meadow School outdoor sculpture.

of the great American universities, you'll find outdoor sculptures all around that speak to inventive thinking.

At the Birch Meadow School, the PTO had already begun to transform an unsightly courtyard with beautiful plants and flowers. They needed a central focus, so they hired me to create a large sculptural plantlike form out of fiberglass. With acrylic paint, kids painted pieces of fabric in greens and blues and yellows, and then, using nontoxic permanent markers, drew images on the fabric relating to their studies: pyramids and sphinxes from their unit on Nubia, math equations, geometric shapes, vocabulary words, masks from the Mexican Day of the Dead festival, flags from around the world, and so on. We glued the fabric to the sculpture and applied a UV-protective coating to keep it from changing color. This giant plant form is the centerpiece of a new outdoor classroom.

Outdoor sculptures allow you to present curricular information in a fresh way,

and I mean this literally: outside where there are plants and birds and sunshine and an abundance of fresh air. Even if you don't use the sculpture as a teaching tool, it will subliminally remind kids of their studies and, of course, stand as a wonderful piece of art in and of itself.

NEW CENTER FOR ARTS AND CULTURE PROJECT, BOSTON, MASSACHUSETTS
TOPIC: FREEDOM OF SPEECH

The New Center for Arts and Culture invited me to create a sculpture that would spearhead a project about free speech. This collaboration involved people of all ages, from six to ninety. Participants explored the topic of censorship and book-burning in Nazi Germany. I then invited them to submit words and phrases that mattered to them, words that they found it hard to imagine living without. Using a silk-screen process, I plastered submissions onto a large sculptural abstract flame. The project culminated in an exhibition at the center called Words on Fire.

Try this in your school. Create a visual framework—a wall, a sculpture—and invite students to imagine a world where they weren't allowed to express themselves, to express love or outrage or dissent. There are so many historical and political themes that lend themselves to this treatment of blending visual art with language: the Civil Rights movement, the women's movement, the history of anti-war political expression, the threat to civil liberties in a time of terrorism. The text immediately attaches meaning to the artwork, even as the art itself pulls and pushes that meaning in different directions.

PRAECIS PHARMACEUTICAL PROJECT, WALTHAM, MASSACHUSETTS
TOPIC: MOLECULAR BIOLOGY

When Malcolm Gefter, a Nobel Prize–winning scientist and head of a pharmaceutical company, saw the molecule-like collaborative sculptures created by students and exhibited at the Whitney Museum in New York, a light bulb went on in his head. These looked uncannily similar to the computer-generated molecules scientists use when developing cures for viruses.

He hired me to create a large-scale virus-and-cure sculpture for his new corporate building. He gave me a computer printout of the molecular cross section of the AIDS virus. When I voiced concern that my sculpture might not exactly replicate a molecule, he reassured me that cellular forms in nature morph into varying

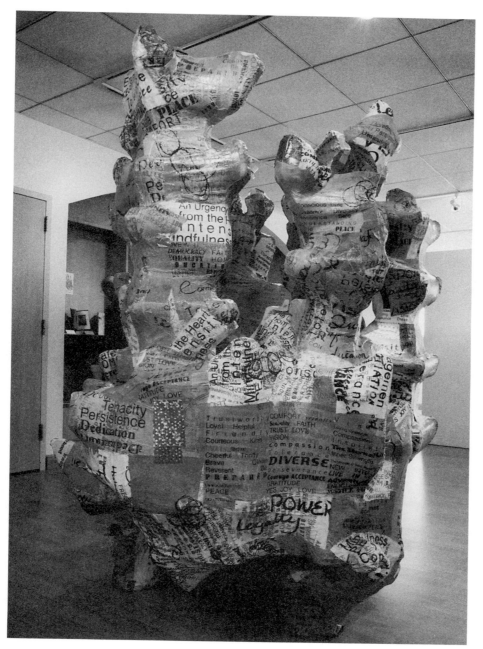

Words on Fire censorship project.

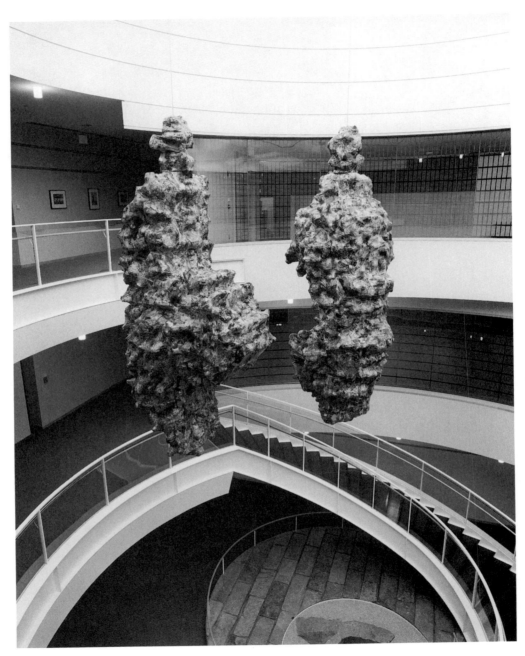

Mark Cooper, Praecis Pharmaceutical Project, *Virus and Cure*.

forms in response to heat, cold, light, and other external influences. In a similar way, when I construct a sculptural form, one shape influences the next.

The beauty, if you will, of a virus and cure is that two molecules fit precisely together to create a healing whole: yet another spin on collaboration. I conceptualized two different sculptures, a virus and a cure, then hired students to help with fabrication, a mast rigger (from the boating industry) to help with installation, and architects and engineers to ensure that the heavy molecules could hang safely from a fourth-floor beam.

Any scientific concept can become more vivid and memorable when turned into physical art. Imagine the artistic ideas your students might conjure up when asked questions like these: How could you use art to explore the workings of evolution? Of entropy? Of reproduction? Of chemical reactions? Of geological formations?

SOMERVILLE/CAMBRIDGE HOSPITAL PROJECTS, SOMERVILLE, MASSACHUSETTS
TOPIC: MEDICAL HISTORY AND RESEARCH

On another medically related project, I interviewed doctors, nurses, patients, and administrators at the Cambridge Hospital, who filled me in on the history of the hospital. I created silk-screens of historical photos of the hospital, as well as of medicinal plants and herbs, and collaged the imagery onto forty different plant-like sculptural forms that we attached to walls in the new main entryway and throughout executive suites and conference rooms. (Sculptural depth was limited to four inches, to comply with building code.) The hospital spends several million dollars a year on translators to assist the diverse patient body, who speak forty-some languages. I included textile patterns from around the world to speak to this diversity.

Background research carried this project. If I hadn't spent nearly a hundred hours talking to people, in the library, and on the Internet, I wouldn't have had anything relevant to say. It's easy for an artist to decide that he wants to make art about a hospital, or about tigers, or about genetics. What's harder is defining just *what* he wants to say about a given topic. Elsewhere in this book, I've encouraged you and your students to vote on a theme and then dive straight into the art-making and get your hands dirty. While this is a great way to generate momentum and

Mark Cooper, Cambridge Hospital wall sculptures, exploring medical ideas and the history of the institution.

Public art for the Somerville Hospital.

excitement, your student-artists will likely have more to express, more details to paint, if they devote time to research first.

Art That Celebrates and Commemorates

BOSTON COLLEGE ARTS FESTIVAL PROJECTS, BOSTON, MASSACHUSETTS
THEME: BUILDING COMMUNITY

Boston College, with eight thousand undergraduates, is always looking for new ways to tie the community together. When the Eagles make the final sixteen in basketball, the entire campus rallies behind them. When a professor wins the Nobel Prize, everyone feels communal pride. The arts can serve a similar unifying purpose.

In 2003, the fifth year of the Boston College Arts Festival, we decided to create seventeen sculptural 5s, which community groups could transform in their own signature ways. (There's no particular significance to the number seventeen; it was

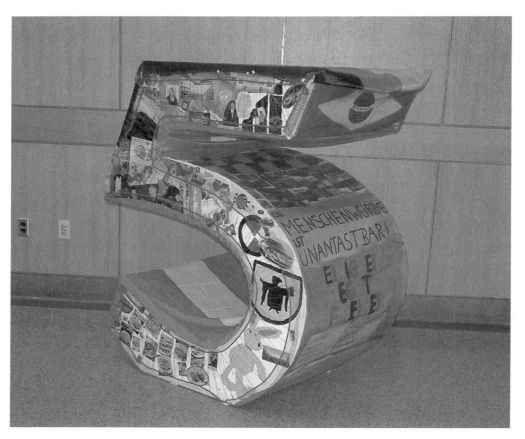

Variations on the number 5, Boston College.

simply a manageable number of sculptures for me to create.) I put out an open call to groups across campus and received dozens of applications, from the Chinese cultural club to the marching band to the student government. A committee chose the winners.

I conducted a mini-workshop with group reps to show them possible ways of transforming the 5s: through collage, painting, attaching found objects to the sculpture, and so on. The groups finished weeks ahead of time, and their 5s were strategically placed across campus, in dorms and major buildings, to promote the festival and celebrate community. During the festival, the 5s were grouped and displayed together in a main plaza. A committee gave out awards for best in show,

most relevant, most poignant, and so on. Amazingly, the UNESCO 5 was bought and sent to Paris for permanent display.

In each of the first five years of the festival, wouldn't you know, it rained. Common wisdom has it that if you tote an umbrella, the sun will shine. So the next year, we chose as our festival theme Umbrellas. I purchased deck umbrellas, made sculptural stands to hold them, and community groups transformed them. They painted patterns, they attached plastic flowers; one group made a Breast Cancer Awareness umbrella.

Hold your own communitywide arts festival to celebrate anything from Martin Luther King Jr.'s birthday to a major anniversary at your school.

INTERNATIONAL CHILD ART FOUNDATION PROJECT, NEW YORK, NEW YORK
TOPIC: CROSS-CULTURAL UNDERSTANDING

Sixty-five children from sixty-five countries were chosen by their teachers to collaborate on a mural of a world map. I prepared a thirty-six-foot-long, sixteen-foot-high plywood backdrop. With an overhead projector, I projected a world map onto plywood and traced its outlines with black marker. I then superimposed a grid over the entire map, both water and land masses, creating one grid per participating child.

I assigned the child from Mongolia to work next to the Brazilian next to the Norwegian next to the Ecuadorian, and kids painted countries other than their own. I wanted the project to be about a world, not a territorial, view. I encouraged them to use blues and greens to start in the water areas, and any colors they wanted on the land areas. In the afternoon, after the lunch break, I reassigned grids so that different kids had the chance to meet and to work on different squares. I also encouraged them to find ways to integrate their paintings with their neighbors' squares. Most kids used color to link sections together.

This project literally tied together the world. We hired translators in six languages, and they gave instructions with megaphones throughout the day. The project culminated in a conference with several thousand people in attendance, including First Ladies and ministers of education. We videotaped the process from start to finish so projects could be replicated back in children's home countries.

Of course, foreigners don't have to be from another continent; they might simply be from another classroom. You can ask seventh-graders to work collab-

oratively with fifth-graders and have the same kind of horizon-broadening effect. You might also find an international sister or brother school in Japan or England or Tibet, send art via the Internet or the mail, and set up a collaborative global project.

Art That Makes Sense of Tragedy

EAST HARTFORD HIGH SCHOOL, EAST HARTFORD, CONNECTICUT
THEME: 9/11

In 2001 I was invited to orchestrate a collaborative sculpture for a student leadership program at East Hartford High School, a tough urban school. I was originally brought in to help students come up with a creative way to celebrate diversity. Then came the terrorist attacks of September 11. The group shifted course and decided instead to create a sculpture called *A Piece for Peace* as a plea for harmony, as well as a salute to diversity. I constructed five giant puzzle pieces out of wood and canvas, and seventy students painted messages and images on panels of paper that we then glued to the pieces. "Under the sun, we are all one," one striking panel proclaimed. The puzzle was exhibited at the Connecticut State House and later permanently installed at the high school.

WELLINGTON SCHOOL, BELMONT, MASSACHUSETTS
TOPIC: COMMEMORATION OF A DEATH

Students from the five fourth-grade classrooms created a hanging sculpture to commemorate a classmate who had died. The boy had been particularly enthusiastic about space, so kids collaged space imagery—rockets, the Milky Way, meteorites—onto a giant teardrop sculpture, which was then hung in a glass-encased stairwell. At the opening ceremony, students shared stories about their friend.

Working collaboratively on this project allowed kids to share their experience of loss in a way that went well beyond the creation of a class sympathy card. In this instance, pictures really were worth a thousand words. And the artwork resulted in something lasting, an enduring testimonial.

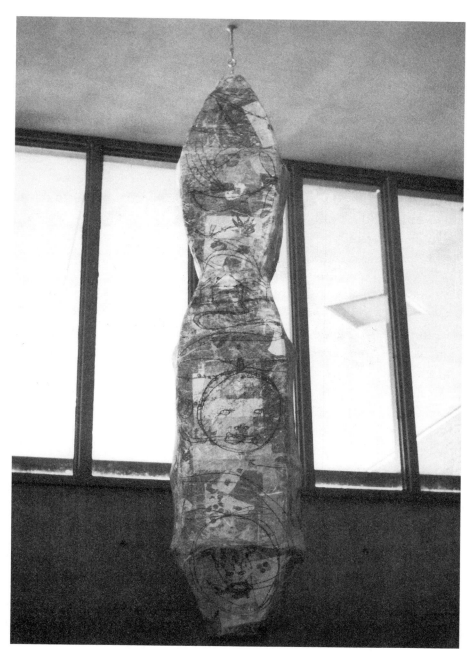

Wellington School, commemorative sculpture.

Art That Marks Transitions

HAGGERTY SCHOOL PROJECT, CAMBRIDGE, MASSACHUSETTS
TOPIC: INAUGURATION OF A NEW SCHOOL

An informal committee of parents, teachers, and administrators decided that they wanted to create a ritual to celebrate the inauguration of a new elementary school. On the day of the celebration, students marched from the old school to the new school, waving flags they'd painted with joyful images of shooting stars, fireworks, kids holding hands, and so on. The small flags were simply made out of pieces of cloth stapled onto wooden dowels. When they reached the new school, students ceremonially placed their flags into holes on the top of a large abstract sculpture.

SOUTHEAST MIDDLE SCHOOL PROJECT, LEOMINSTER, MASSACHUSETTS
TOPIC: MARKING THE TRANSITION FROM EIGHTH TO NINTH GRADE

Students in thirteen eighth-grade classes created a collaborative sculpture to mark their transition to ninth grade and to demonstrate what they'd learned during the year. After a series of discussions, students decided to collage imagery about democracy onto a triumphant sculpture. We spent a lot of time talking about how to render democracy in paint and visual form. Whenever students resorted to clichés—a peace sign, for example, or clasped hands—I required them to somehow transform the pictures to make them more personal and unique. The peace sign became a face, and the hands a patterned background that repeated sporadically throughout the sculpture. In this case, as in most, detailed signage was important to explain the project theme and motivation.

DRISCOLL SCHOOL PROJECT, BROOKLINE, MASSACHUSETTS
THEME: FACES IN THE MILLENNIUM

Using squirt bottles filled with acrylic modeling glue, everyone in the school—from students and parents to teachers, janitors, and the principal—made very simple, childlike self-portraits on little squares of paper: Here we are, individuals within a greater community, at the millennium moment! We took the paper squares to an industrial foundry that turned them into bronze tiles fairly inexpensively. (We

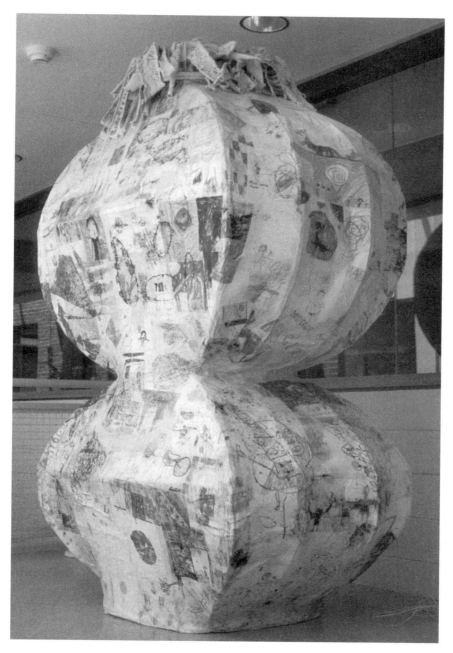

Haggerty School, inaugural sculpture.

saved a huge amount of money by going to a foundry that made nuts and bolts and fire poles rather than to a fine-arts foundry.) The bronze tiles were bolted to a fifty-foot-long, six-foot-high brick wall near the entryway of the school.

Consider doing something on a smaller scale in your classroom. Kids can make an inexpensive classroom self-portrait using pencil and paper, or paints, instead of acrylic modeling paste and bronze. Play with the idea: have every portrait include a hat, or a reptile, or a cactus, or a cupcake.

Public Art

DECORDOVA MUSEUM PROJECT, LINCOLN, MASSACHUSETTS
TOPIC: PUBLIC ART

Under the tutelage of curators from the DeCordova Museum, which boasts one of New England's finest sculpture gardens, eighth-graders from the Edwards Middle School in Charlestown, Massachusetts, researched the history of both commemorative and public art: from General Ulysses S. Grant mounted on a horse to the Vietnam Veterans Memorial. They took field trips to outdoor public sculptures, reviewed books and websites on public art, and then created a whimsical sculpture of their own that was permanently installed in the school.

BOSTON FROG POND PLAYGROUND PROJECT, BOSTON, MASSACHUSETTS
TOPIC: DIVERSITY

This collaboration involved seventy-five elementary-school children, ages six to eleven, from an afterschool program at the Citizen School in the Dorchester neighborhood of Boston. These students became the authors of a major work of public art in a major playground in the major park of the city. The project didn't require much skill, money, or time, yet it continues to delight thousands.

Teachers prompted children: "If you were a frog and this frog had great potential, what would it do? Would it be a surgeon, a trapeze artist, a professor? Would it Hula-Hoop for ten days straight?" Using colored markers on paper, children drew four-inch frogs in every human endeavor they could dream up: frog ice skaters, ballerinas, chefs, firefighters, presidents, doctors, a bunch of swimming frogs in a race, carpenter frogs with hammers and screwdrivers, artist frogs outfit-

ted with paintbrushes and palettes. Some kids drew frogs freehand, others used prepared outlines.

The kids helped me glue the frogs next to one another, in clusters, on ten long pieces of paper. These were scanned into a computer, turned into a digital file, and then given to a design fabrication company, which turned them into ten three-foot-long, six-inch-high outdoor resin tiles. A union tile setter embedded these colorful mini-murals into the side of the concrete bench that surrounds the playground.

This project lives in the Boston Common just below the State House in a highly trafficked playground for small children. Frederick Law Olmsted, the designer of the Common and a major landscape architect of the late nineteenth century, had a utopian view about parks: parks are democratic places where people from all religious, economic, and cultural backgrounds meet and share the day, picnics, trees, wading pools. The frogs represent this kind of Olmstedian ideal: frogs of different colors and walks of life meet in a playground used by thousands of citizens and visitors over the course of the year. The original collages were framed and installed in the school where the afterschool program was housed.

Invite your own students to narrate and illustrate their own animal stories. Choose any cute creature to serve as a main character and, as children create personified drawings, use this opportunity to explore a variety of social issues with them: bullying, friendship, blended families, and so on.

This is a final way that art connects to the larger world: Every project mentioned in this book is a work of public art. These projects are destined to be seen by the general community; publicity is part of their conception. Public need not signify the town square, or Times Square for that matter, it can mean your school courtyard or a wall of the second-floor hallway. Wherever the art gets placed, the public nature of these projects gives them validity.

Your kids can paint a picture, take it home, stick it up on the refrigerator, and share it with family and friends who drop by. While public, while wonderful, this display is limited. It's fundamentally different to exhibit students' collaborative art in a highly trafficked school lobby or in a museum where a larger public sees it. Students are speaking to an audience that isn't invested in them like a mom or

Boston Common, Frog Pond, work of seventy-five students.

dad or grandma. They're sharing their artwork with a neutral, objective audience. When you're a kid, the refrigerator is always reserved for you; the school lobby or a museum wall, on the other hand, is coveted, high-priced real estate. When your art hangs there, you're the real thing. You've come into your own. You're a happening public artist!

Chapter Seven

The Stakeholders

Let's say that you like to think big, even extravagantly. Let's say you'd like to move a project beyond the confines of a single classroom and involve everyone in a school, or in two neighboring schools, or in an entire town, in a huge collaborative art project. One thing's certain: To pull off a large-scale project, you need to bring more players onboard. Single-handedly, you're not going to be able to manage many people, coordinate schedules, raise money, and procure supplies on your own. You're going to need help.

This is where stakeholders come in.

A stakeholder is anyone and everyone who is invested in the project and the outcome. We live in an increasingly interrelated global community, and so I urge you to cast the widest net possible: teachers, students, parents, funders, principals and superintendents, school board members, local businesses, community organizations, museums, and so on. The benefits of bringing these players onboard far outweigh the initial effort required to do so. It's worth it because you can do more with more people involved; everyone thrives with the added energy and wider circles of recognition. And it's worth it educationally: the civics lessons in democracy are that much richer and deeper when kids see many people involved, mostly volunteers driven by a common goal of creating something special.

As the orchestrator of a large project, you need to feel secure enough in yourself that you can share both the responsibility and the glory with others. Facilitate your project in such a way that everyone feels it's *theirs*. Present these projects as win-wins because they *are* win-wins. I have found that most people are eager to connect with ambitious projects by kids. Teachers have a stake in success. Students have a stake in success. Funders have a stake in success. Everyone wants these projects to succeed, and everyone has a role to play to make that happen. If a partnership is to succeed, all the individual partners need to benefit *along with* everyone else. No one benefits at anyone else's expense. What's in the individual's

best interest is also in the best interest of all: What's good for the leader is good for the participant is good for the funder, and so on. Power doesn't rest with the artist-genius. Everyone gets to be the artist-genius. Everyone who participates in any way at all is part of the artistic collaboration.

As you set out to bring various constituencies onboard, confidence is key. You need to feel confident that people will buy in, and, in order to get that buy-in, you need to build the confidence of others. How to build confidence? For one, anticipate stakeholders' questions and be prepared with answers. Also be prepared to answer a question that, although not usually asked, is in the back of everyone's mind: "What's in it for *me*?" The following breakdown of potential stakeholders will help you to anticipate the most common questions and prepare the most persuasive answers.

Principals and Superintendents

The buck stops with principals and superintendents. They're responsible for money spent, time allotted, and the artistic statement that is made. Whatever good or bad happens in these projects, they take ultimate responsibility. So you need to get them solidly committed.

If you're aiming to involve the entire school or if the artwork will be highly visible, then you'll need the principal's approval and perhaps the superintendent's as well. Even if you don't think this is necessary, err on the conservative side and make the goodwill gesture to get the thumbs-up. At the very least, they'll see you're doing innovative things.

At your first meeting, assume an optimistic attitude. Assume they'll be interested and that of course they'll want this to happen. As quickly as possible, move them into a participatory role: "Here's what we want to do. Do you have any additional ideas? How would you like to participate? Would you like to see more examples? Would you like to be involved in fundraising?"

Here's what you should carry with you to this meeting: this book, a budget estimate, a funding plan, an action plan, a materials plan, a clear idea of who will participate, options of where artwork might be displayed. The more information you can give a principal and superintendent up front, the better. In your pitch, stress the educational value of your project. For example: "This is a visionary, transformative curricular process. It will cement together what kids are already

learning." Promise to do your best to keep financial and time costs to a minimum. In other words, for a minimal investment, the rewards are huge!

Add in a safety feature by giving them editorial say: "You can check in at any time; if anything's problematic, we'll adjust." Ask them up front if there's anything in particular they'd like to see or like to avoid (profanity and violent images, for example). Reassure them that while kids will have a lot of expressive freedom, this doesn't mean that anything goes. I did a huge project in Washington, D.C., with the Children's Museum, the Corcoran Museum, and schools throughout the District and Maryland. One girl painted a 3 ft. x 9 ft. painting with the statement *4 Q be loved,* made specifically to fit on the back of a city bus. I had given the chief of the D.C. mass-transit commission the right to weigh in at any point—and he did, saying: "We can't have a gang logo driving around the streets of Washington, D.C." I had no idea! Other than this one incident, no one else has exerted editorial control in any of my projects. By making a point to stay in continual conversation with stakeholders, you minimize the risk of surprises.

Ultimately, you want your principal and superintendent to go to a meeting of their peers and proudly display what you and your students have created. You want this level of enthusiastic buy-in! Every principal I've worked with has touted the projects to teachers and showed up at fundraisers. At one school, the principal was the first to make a mark on the canvas.

School Board Members

Members of the school board come to the reception, they give speeches, and you thank them for all their support. Collaborative artwork is about generosity. While they may have had little or nothing to do with making the art happen, it costs you nothing to acknowledge them at the reception. (Be sure to invite them!) Elected school board members, especially, are eager to attend events that mean a lot to their constituents. And they're always eager to see success demonstrated in a public way. They'll be more likely to approve funding for a future project, related or unrelated, when they see such benefit come at such low cost.

Faculty

Get faculty invested early on, and their commitment and enthusiasm will drive the project. What's in it for teachers who aren't orchestrating the endeavor? A lot, I

believe. Students think like artists, tackle complex projects, investigate the curriculum from a new angle, and experience democracy in action. When you present the project to your colleagues, tie it to larger curricular goals in the school and suggest the various ways learning will happen: Present the project as a serious, academic pursuit. Make an announcement at a faculty meeting. Talk to teachers individually. Involve allies first. Ask the principal to publicly voice his or her support.

If possible, conduct a faculty workshop and walk teachers through the same artistic process that students will be using. "Aha! This is how the project relates to our curriculum!" "This is how kids will learn about working together!"

Resisters

While most projects come off without a hitch, err on the side of prudence and prepare for potential resistance. *Expect* that some people will hesitate to jump on-board for any number of reasons. Perhaps they're too busy. Perhaps they think art's a waste of time. They say that art's silly or that it costs too much money. Resistance might come from a predictable or unpredictable place. It could come from the art teacher who has a differing idea about how art is made. It could come from a teacher who is preoccupied with testing. Don't let these people slow you down or derail the project. Respect their input and invite their participation, even if it's minimal. Ask the art teacher: "We're making drawings on paper today that we'll collage onto this larger painting. Could you do a quick sample sketch?" Ask the custodian: "What's the best way to hang this?" Ask the business manager: "Whom might we approach for funding?"

Give resisters careful thought—What are their interests? How do they spend time outside of school?—and approach them in a way that plays to their strengths and interests. A constant goal should be to keep as many people as possible in the conversation and to help them feel excited about their participation.

Funders

Like most everything in the world, these projects cost money. Unless a school has budgeted specific monies for collaborative art projects, which is rarely the case, you'll have to raise the money yourself or in collaboration with involved parents or other funding partners.

If you decide to raise money yourself, you can stage any number of fundrais-

ing events: hold bake sales, organize silent auctions, throw a big party. Recruit art teachers to donate pieces of their work to be auctioned. Recruit music teachers to perform in a fundraising concert. Ask parents who are talented woodworkers, cooks, knitters, or tennis players to donate or auction their talents. Perhaps a set of parents would be willing to host a dinner at their home where guests make a contribution to socialize and support the project. PTOs often have money for projects like these, or members might be willing to help with fundraising.

If you decide to apply for grant funding from local or national foundations, from state agencies that support education and the arts, or from other funding partners, keep several things in mind. First, remember that funders look for great projects. They look for ways to use their monies well; in fact, the public trusts them to do so, hence, their tax-exempt status. They want the projects they fund to succeed in the biggest and most public way possible to demonstrate that they've served the public.

Whenever possible, avoid doing business by letter or e-mail and meet personally with a funder to open up a dialogue. What you'll stress in your meeting depends on the funder and the funding priorities. Do a little research: What are the funders' buzzwords? What are their funding criteria? What other projects do they fund?

Funders will want to sense that everything's in place at the start. Be prepared to tell them where and when the project will happen, exactly who is going to participate, and where you'll display the finished project. Consider conducting a trial run; just as architects build small-scale models before launching into a full-scale project, you can recruit a handful of students and make a scaled-down replica of your larger collaborative art object to show funders and other stakeholders. I created a number of larger bronze tiles that were sold at a fundraiser for the Driscoll School project to give funders an idea of what they would be supporting. In Washington, I displayed a collaborative art sample to inspire additional funding. There's nothing like seeing a real piece of artwork to clinch a deal.

"How much is this going to cost?" This is one of the first questions funders will ask. But if you set a price up front, you might scuttle the opportunity before you even get started. So get funders to agree, first off, that they want this thing to happen, then deal with the money: "Let's get in agreement that we're going to do *something*. Now let's visualize our dream project and see if we can make it happen."

Once you've established agreement, remain flexible. You may not be able to raise all of the monies you think you need. I typically tell funders at the start that I'll find a way to work within their budget so that cost doesn't prohibit us from moving forward. This means you have to be accommodating and creative. It also means the project's a go. Maybe you don't make five sculptures, you make one. Maybe you shrink the scale; the sculpture stands ten feet high, not sixty. There are also ways to cut corners and trim expenses on materials. If you want to make a durable outdoor sculpture that can withstand the elements, fiberglass is cheaper than bronze. Even when it comes to paper and paints, there are ways to save. Art-supply stores often offer educator discounts and might be willing to make donations. Seek material donations wherever possible: supplies for the art project itself, food for fundraising events, goods for auction, and so on.

Parents

Bring parents into the loop early on. Give them advance notice that the project is going to happen. Send out a special mailing or flyer or e-mail announcement, including a color photo of a past project or of one of the projects featured in this book. Highlight the democratic aspects of this approach: collaborative art projects bring everyone together to participate on equal footing. This is above and beyond the normal curriculum stuff.

From the start, suggest ways that parents can get involved as volunteers. For example, they can help to design the closing event. Those with an engineering bent can figure out how to secure a sculpture to the ground. Parents can reinforce this process at home with their children and help to extend the curriculum outside of the classroom. Encourage them to ask their kids about the project: How's it going? What image are you going to create? What theme did your class decide on? Where do you think the final object should be displayed?

Parents can also help raise money. At the Birch Meadow School in Reading, Massachusetts, parents were the driving force behind a fundraising effort for a large collaborative sculpture. After getting turned down for funding by a Massachusetts state agency, they applied for a grant from the Target Corporation and were awarded two thousand dollars in seed money. They held a silent auction featuring kids' artwork and products donated by local businesses. They raffled off baskets of items created by students: book baskets, craft projects, sports baskets.

They threw a kickoff Meet-the-Artist dinner at the school. People paid twenty-five dollars per family to attend, local restaurants catered the event for free, babysitting was provided in the gym, and I showed slides of my work. Their persistence paid off; after two years, parents had raised the fifteen thousand dollars required to pay for materials and for my time to make the sculptural form and to conduct workshops with students.

Local Businesses

While local businesses may not be in the position to grant direct funding, most are happy to support community projects in other ways, and many believe it's their moral obligation to do so. A hardware store can give you tape, nails, picture hangers, glue. Paint stores can supply you with paint, brushes, drop cloths. A local restaurant can donate food for the reception. Any of the above can donate T-shirts emblazoned with their logo for kids to wear as work shirts.

A friend of mine who has run foundations for years frequently comments that he's in the business of funding *people,* not projects. Every time you meet someone face to face, you radically increase your chances of that person supporting you. Don't depend on e-mail or a letter. Go to the store, and be willing to go back several times. Ask to speak to the managers, have a friendly conversation in which you introduce yourself, explain the project in broad terms, and give them as much flexibility as possible: "Anything you can do will be appreciated." Have suggestions in mind—"We could really use paint"—and know how much of each item you need. For one project, I approached a local art-supply store and told them I would acknowledge them in all promotional and newspaper write-ups. In return, they offered me gallons upon gallons of glue that was too thick to sell. I happily accepted, and later watered the glue down. They also offered me remainders of paint, mostly orange and red, no blue or green. "Great!" I said. "I'll take anything and everything." I got blue and green paint elsewhere.

If it feels comfortable, bring some kids with you and invite them to describe the project. Turn this into a learning experience in salesmanship and marketing. It may be more efficient, however, to do this business piece on your own.

Present yourself and the project as professionally as possible. This will distinguish you from all of the other people looking for donations. Stress that this project is going above and beyond. It's a big, complex, highly visible educational

project that involves more partners than most. Take this book with you to show examples. Don't hesitate to put a spin on the project that will excite people. If this were a news story, you'd need an angle that would move an editor to run your story. Similarly, tell a great story to everyone you approach. You want stakeholders not only to be fascinated *by* the story, but also to want to get *involved in* the story. Emphasize that their contribution is vital and that the project wouldn't be the same without them.

A final thought: Be sure to mention the nonprofit status of your school or PTO. This way if the business wants to deduct their gifts, they can.

Outside Experts

Don't hesitate to hire or solicit the volunteer help of outside experts as you need them: a structural engineer or carpenter to help with installation, a mover to move a large object, a foundry to help cast in bronze, a mason to lay tile. Engage experts in the process and ask them to be as resourceful as possible with your money. What's in it for experts? In general, people are happy to work for a good cause and are grateful for the chance to do so. If they happen to be parents from the community they may well work for free. If they are small-business people, they may donate services or reduce their professional fees. At one school, for example, two parents, one an engineer and the other the owner of a construction company, teamed up to design and create a permanent foundation for the outdoor collaborative sculpture.

Museums

The bottom line for museums: They want people to interact with their collections. Most museums have wonderful educational departments and art educators who are eager to tie in to programs like these. Your kids take a field trip to a museum, get inspired, and interact with art in a whole new way. In turn, the museum has opened its doors to a new generation of patrons. Most, if not all, museums have a mission to reach a large public; you are helping them with their job. Open a dialogue and see what ideas emerge. Be sure to invite the museum staff to the unveiling. They will happily record their participation in their annual report.

Billboard Companies

By and large, billboard companies are considered public enemy number one. In the minds of many, they pollute our environment with big, ugly structures and advertisements. But who says we can't take the infrastructure they've put in place and use it to benefit and beautify the environment instead?

Let's say that you and your students decide to create a full-scale billboard to display out in the community. Call the billboard company, ask who's in charge of public relations, and let them know that you want to do a community project in the area. Schedule a face-to-face meeting and bring this book along as a resource. Guarantee that you won't put up something that's controversial (no guns or sex, for example). This isn't to say that your billboard can't be totally crazy, or edgy, or visually wacky. It just needs to be wacky in a way that the company can deal with. Most of the billboards kids have created with me don't look like paint-by-number pictures. They typically contain wild patterns and a surprising randomness that reflects the creative contributions of many individuals.

At any point in time, most billboard companies have empty space somewhere. Don't pressure them: "I need this billboard in this location at this date." If you try to pin them down, they'll likely say no. When you give them flexibility, they are typically accommodating: "When you have empty space in this general area, let's make this work." Once again, present this as a win-win for all. Bring the company in as a stakeholder—with something *at stake*—and they are much more likely to make this work. Billboard companies know their reputations as eyesores and are eager to be seen in a positive light. It costs them very little to put up your billboard image, and that, in turn, boosts their own public image.

The Media

English teachers provide students with opportunities to get published. Science teachers prep students to compete in science fairs. Similarly, you can create opportunities for your students to introduce their artwork to the larger world and gain public recognition for their efforts. This is where the media comes in.

Newspapers, TV stations, public radio, and other media outlets are constantly on the lookout for remarkable and interesting stories . . . and have you got one for them! You're bringing a community together in an unusual way. You're doing

a twenty-first-century barn raising in the form of a collaborative art project. Contact the editors of the Education section of your local paper. Try the art editors too, although often they don't know what to do with projects like these because the artwork doesn't spring from a singular visionary artist.

The more information you give an editor or writer, the better. Try pitching the story backwards: "We're going to have a closing event at which all sorts of amazing things will happen . . ." and then invite them to cover the project from beginning to end.

Time and again, I've seen kids react the same way when they see themselves or their peers in the news. It's an epiphany: I can matter to the larger world! Public recognition doesn't happen only to somebody else. Suddenly, they are not *students* making art, but *artists* making sophisticated objects. Even if only one or two students get interviewed or quoted, every participant realizes "that could've been me" and that the project belongs to everyone. And remember: Every time a story runs in a newspaper or on a local TV station, your collaboration grows exponentially bigger.

Politicians and Community Leaders

Politicians' mandate is to serve and build community, and, more and more, elected officials are coming to realize how the arts can improve and raise community esteem. Invite community leaders to visit the school, meet with students, and see art-making in action. Invite local politicians to speak at the final ceremony; typically, they are delighted to meet their constituents in a guaranteed-friendly forum. And there is no better advertisement for arts in the schools than providing a first-hand experience of student creativity, unity, and wherewithal.

Creating community is thrilling and, for me, one of the most satisfying aspects of the art projects I do with children. Collaborative art partnerships are surprisingly easy to put together, and once you get started, they tend to build on themselves; one contact leads to the next. Communication is key. Aim to make your project so clear—the planning, organization, creation, and funding—that by the end of the closing ceremony, every stakeholder could do it by him- or herself.

Chapter Eight

Last Things: Evaluation, Documentation, Closing Ceremonies

We live in an age when the public demands accountability of educators—not a bad thing in itself, although accountability can take misguided forms. It is also a time when art education, in particular, is frequently asked to defend itself in ways that many other disciplines are not. This question comes up a lot these days: Does art have a place in a child's formal education? Needless to say, I think art in schools needs no defense. Or rather, art in schools is eminently able to argue for itself. In particular, I believe the kinds of collaborative projects I have been involved in—with their rich possibilities of curricular tie-ins and lessons in democratic co-operation—can be showcases for the success of art in schools.

The key is making a case for art, and making it in a powerful, public way. I use three major tools to make the educational value of these projects visible and public: evaluation, documentation, and closing ceremonies. As a bonus, each of these tools actually enhances the collaborative art-making experience.

Evaluation: An Invaluable Tool

Conducting a project evaluation often feels akin to getting a shot. Although you need it, you sure don't enjoy it! I urge you to turn this notion on end. Evaluation of an art project like the ones in this book needn't be painful, nor a burden, not if it's done in a meaningful way. You need to make evaluation matter, to make it useful to the process. If your project is supported by outside funding, you'll need to follow evaluation guidelines stipulated by the funder. But even when evaluation isn't a requirement, consider it a key project component. A sailing analogy is per-tinent here: When setting out for a sail, you start by charting a course to take you from point A to point B; yet rarely, if ever, do you stay trim-sailed on course. In response to the changing winds and tides, you need constantly to reevaluate and

readjust to get where you're going. Similarly, once you formulate your project goal (point B), ongoing and rigorous project evaluation allows you to adjust or change course as needed to reach it. Without a means of measuring your progress or lack thereof, it's likely you'll wind up at sea.

There are lots of ways to collect evaluative data: group reflection, qualitative interviews, quantitative pre- and post-project questionnaires, simple observation. I suggest making evaluation ongoing, from start to finish; this way, you can fine-tune as you go. For example, you might conduct small-group interviews at the end of every week. Pose questions to the entire class, then meet with small groups of kids and ask for their feedback. Or, to save time and give kids more authority, write questions on the board and ask pairs of kids to address and to document their discussion points and then report back to the class.

It bears repeating: Once you've gathered your data, by whatever means, you need to *apply it* and make changes accordingly. You've taken your bearings and discovered that you're even a degree off course? Now's the time to adjust.

Evaluate the Process, Not the Product

When Debra Singer, curator of the Whitney Museum, was asked about kids' collaborative art exhibited at the museum, she said that the *process* was integral to evaluating the art. According to her, the collaboration itself, with its overarching concept of community, is the heart and soul of the art created.

I agree. Although the final product matters, and, ideally, everyone feels great about what they have produced together, artistic judgment is *always* subjective. Even if the chief critic for the *New York Times* raves about your work, this is still only one opinion. Moreover, in a collaborative project, you've created an open-ended, multilayered form that allows for a large range of interpretations. In order to assess the merit of the artwork itself, you'd have to evaluate each student's stylistic approach based on its own criteria. It's challenging, if not utterly unrealistic, to compare abstraction with realism with minimalism with cartooning.

The quality of the final product is absolutely key to the success of the project: it's a great motivator for everyone involved, and it is its own reward. But in an era where the value of art in schools is not taken for granted, and is even under attack, trying to get agreement on the aesthetic value of the finished product is not politically or practically the best way to argue for the value of the art-making experi-

ence. Too many people are willing to dismiss this kind of quality measurement as mere taste and to stop listening.

Early on in my creative life, I was influenced by asymmetrical, somewhat crude Japanese ceramics. I loved the humanity, the cracks, the imperfection, and the organic forms. In other words, I fell in love with something that was *imperfect* by any objective standard. As my interests changed over time, I became drawn to highly decorative porcelain objects. Years later, while working on a project in Washington, D.C., I visited a new gallery at the Smithsonian that featured crude Japanese ceramics. My immediate reaction: "These are awful!" Then the old Mark kicked in and I started seeing their beauty once again. This reminded me of what a strong role fashion plays in appreciating art objects. If this kind of shift can happen even within one viewer, think of the problem of getting agreement across viewers. So in a way, although I value the objects that emerge from these collaborations enormously, justifying their inclusion in the curriculum on the basis of what people think of the finished object is too subjective.

To determine art's usefulness, other people have tried measuring the effect of art on students' math scores. I think this is the wrong tack. Of course, I have argued that art can and should be fused with other aspects of curricula, that it can enhance and provide another way into the study of any field, from history to math. But that doesn't mean that the particular habits of thinking that art strengthens are the ones that can be measured on standardized tests. The ability to think creatively—or cooperatively—doesn't fit neatly into multiple-choice exams. Standard art exams, even where they exist, can't test what's interesting about being an artist, thinking like an artist, solving problems like an artist. They can only test historical art facts and other memorizable items.

So, in addition to assessing what students learn while conducting background research for a project—which can be substantial—I suggest you evaluate (and document) the *quality of the experiences* kids have while making the final work: the experiences of learning to collaborate and work together as a community, to problem-solve, to come up with creative collective solutions, to organize and understand the components of a complex process. These are all essential life tools. For example, have participants had the experience of generating ideas? Of debating? Of being treated with respect by others in the group? Of having their individual voices respected in the greater conversation? Step back periodically and ask kids

questions like these. You can also craft a simple evaluation form for students to fill out.

Setting Goals Is Critical

Set short-term as well as long-term attainable goals for both group process and artistic product. Here are sample questions, grouped by category, that you might ask your students—and yourself—throughout the life of the project to ensure that you are staying on track, and to demonstrate to fellow teachers, parents, administrators, and the community that something genuinely valuable has happened in their children's education.

THE PROCESS

At some stipulated point, at the end of every class or every three classes, have a conversation with your students about their working process.

❊ What are you noticing about the way we work together?

❊ Does everyone feel like he or she has made a contribution?

❊ Is there a way you'd like to contribute that you haven't?

❊ So far, what has been the best part of working with others? The hardest part?

❊ Has everything felt fair? Can we make anything more fair?

❊ Are you having fun? What could make this more fun? (Expect that most kids will say they are having fun. But *fun* can mean different things to different students. So ask lots of follow-up questions: "Help me understand what you mean," "Say more about that.")

Pause periodically to evaluate *your* influence on the working process:

❊ Have I created a working system where everyone has the opportunity to contribute?

❊ Does each participant have a sense of ownership and achievement?

❊ Is everyone participating?

❊ Have I helped to generate team spirit?

* Have I been careful not to play favorites?

* Are students demonstrating respect for each other and for everyone's contribution?

* Have I set up an effective and fair process for decision-making (e.g., choosing project theme and form)?

* How can I be a better teacher?

* Are my instructions clear?

THE PRODUCT

* Are we on schedule?

* Do we need more paint?

* Is manufacturing going smoothly?

CURRICULAR LEARNING

If the artwork connects with a curricular topic, you can evaluate kids' knowledge base of the topic area.

* Have we met our curricular goals?

* Do students have a greater understanding of a given subject matter?

* Can students articulate that understanding?

ARTISTIC LEARNING

You can evaluate knowledge gain in specific areas.

* What is shading?

* What is hue?

* Can students list the complementary colors in this painting?

LARGER LESSONS LEARNED

Most of these questions are best posed at the end of the project.

* If we were to do this again, what would we do differently?

❊ If we're not entirely happy with our creation, does this mean we've failed?

❊ What are some of the important things you learned during this project?

❊ Do students have a working understanding of the democratic process?

Don't expect students to grasp the larger lessons learned all at once. If even one kid can articulate, for example, that there aren't winners and losers in this process, consider this a triumph. If only one kid gets that art is about risk-taking, experimentation, and invention—about *not* playing it safe—consider this a powerful paradigm shift for the entire group.

Documentation

Signs are everywhere, and for countless good purposes: signs direct us, inform us, protect us, persuade us, caution us, help to preclude social chaos, and on and on. The best signs achieve their ends succinctly: STOP. DETOUR. CHILDREN AT PLAY. GOING-OUT-OF-BUSINESS SALE. WELCOME HOME. When trying to get to the airport, all I need is a silhouette of an airplane and I know what road to take.

Signage for artwork can be simple—DRAWN BY MRS. KILMER'S THIRD-GRADE CLASS—but is typically more detailed. When artwork is installed in a public space, and especially when it aims to make a social statement, it's unsettling not to have an explanation of what it is and why it's there. I recently saw an installation of photographs at the Open Society Institute in New York depicting Africans walking in the desert. Without the signage, I would not have known that these were displaced peoples and that 2.5 million out of a population of 5 million had been murdered.

In your case, the collaborative *process* is so conceptually key to the artwork, you must explain this to your viewers. Increase your viewers' understanding of the working process, and you heighten their appreciation of the final product.

Talk about signage with your students: "What's the best, most fun, most effective way to communicate with our viewers through signage? What do we want our audience to know? How will we communicate our ideas through our sign? How will we get our audience to notice it? Shall we get inventive with font, color, framing, or sign surface? At what point have we given viewers too much information, which may cause them to zone out?"

DOCUMENTATION PRECEDING THE PROJECT

At the outset, once you've decided you're going to do a large collaborative project, post examples to generate enthusiasm. Teachers, parents, visitors to the school, everyone will see what's coming and get excited. A dialogue has begun! Display past projects, if you've done them: photographs, models, the collective works themselves. If this is your first project, copy photos from this book or from other artists as examples, blow them up, and provide written explanation.

DOCUMENTATION DURING THE PROJECT

As you get under way, keep the project on everyone's radar screen. Blow up and post working drawings, step-by-step diagrams, bullet points of students' ideas, or photographs of students hard at work, hammers or paintbrushes in hand. You can also display the actual art object while it's in process, along with signage explaining the project's history and development.

SIGNAGE FOR THE CLOSING CEREMONY

For the final reception or closing event, create signage documenting the art-making process and the ideas that motivated the project. At the Boston Museum of Fine Arts, Project Zero created a documentation book that included photographs of the artwork, interviews with participants, and explanations of the working process. We displayed the book alongside the artwork and gave copies to key stakeholders. With your students, craft your own homegrown version of something like this, or make it even simpler: a handout or small brochure that every attendee can take home. Even a one-sided card can be a work of art! If you have the money, photograph a detail of the art object and have this transferred onto fridge magnets, T-shirts, or hats.

PERMANENT SIGNAGE

Permanent signage should be simple: a brief paragraph or two explaining the process and the purpose behind it: "This is a mixed-media artwork created by every member of the 2005 Birch Meadow School reflecting their thoughts on [what they are learning, have learned, or are about to learn]. Each student contributed a painting and helped apply it to the sculpture."

If you have the money, hire a sign company to make a permanent sign or plaque. A simple typed explanation will also do. Put this in an inexpensive Plexiglas frame and hang it near the installation, or ask a copy shop to print your text on a large piece of foam core.

Permanent documentation benefits both viewers and artists. As they read the sign, viewers not only gain a better understanding of the process, but they also can imagine themselves as participants *in* the process. For the artist-participants, signage lends importance to their work and guarantees that their efforts will be appreciated for generations to come. Signage also allows students to analyze and understand their work from a more objective vantage point.

ART AMBASSADORS

Students' charge is ongoing: "Your work isn't done yet. You've worked together to create something that never before existed. You were responsible for its creation and are now responsible for bringing this creation into the world. You are the artwork's *ambassadors*." When parents, friends, siblings, or the principal ask about the piece, students should be the ones to explain what it's about and how it came about. Give students formal and informal opportunities to present their work and its history to others. As public speakers, they'll get to think and talk with clarity and conviction about their accomplishments. Explaining the process is itself part of the art.

Closing Ceremonies

From the get-go, your project builds toward a closing ceremony. Artists don't make works of art to store in a closet; art is made with the intention of communicating ideas, and in order to have a conversation, you need to have an "other." When I see someone take time simply *to look* at my artwork, I see what I've created through different eyes. Likewise, your students will experience their creation in a different way when in the company of other viewers.

All this is to say: Don't let your project fizzle away! A closing ceremony isn't optional, it's a requirement. The ceremony completes the experience and allows participants to reflect on all that they've done prior to this. It also validates their efforts: "What you've done is worthy of public appreciation!"

You don't need to break your back over this. You can plan the closing ceremony for weeks, or you can pull it off extemporaneously.

If you decide to stage a major event, make sure that students and parents and everyone you want to be there will be there. Do all you can to avoid a woeful anticlimax. Invite every one of your stakeholders, anyone who has in any way been involved in the project, including funders, administrators, teachers, local businesses, secretarial staff, maintenance and facilities crews who've helped clean up messes, and so on. This may well be the only time when all the collaborators on the project can meet in one place and congratulate one another.

Give people roles at the event—set up, clean up, food table, student supervision, MC, activity assistant, drink supervisor—and they're more likely to show up. Of course, if you've involved stakeholders throughout the process, they wouldn't miss the closing ceremony for the world. They'll be eager to celebrate *their* success, the communal success, along with the students. Metaphorically speaking, you've raised the barn together!

Send out an invitation, preferably one that students have a hand in creating. Use it as an educational tool to let everyone know what you've been doing and why the project is important. If you send an e-mail notice, include an image of the artwork and follow up with a reminder.

Hold your ceremony on site with the artwork, be that a library, a school foyer, or a park. At the conclusion of the I Have a Dream project celebrating Martin Luther King Jr. Day, parents set up tables under a billboard on the Fourth Street corridor, a busy street in Washington, D.C. As cars whizzed by, everyone ate cake and toasted the artwork with cups of ginger ale. TV reporters and staff from the two major newspapers, the *Post* and the *Times,* interviewed students, and the story made the five o'clock news.

ACTIVE AND COLLABORATIVE

Make the closing ceremony as *active* as possible. If all you can do is make an announcement at an all-school assembly, ask participants to stand up to take credit. But you can go well beyond this. Think big, beyond applause and eating apples

and cookies. At one school, students marched from the old school to a new one waving fabricated flags. At another, a Wampanoag Indian blessed the new outdoor sculpture. Student-artists from East Hartford High School were honored in a formal ceremony at the Connecticut State House. More than one site has wrapped a huge red ribbon around the artwork and kicked off the closing with a ribbon-cutting ceremony.

If possible, give everyone at the closing a taste of collaborative art-making. Arm students, and adults too, with disposable cameras and ask them to document the event. At a closing event at the Whitney, we set up different stations: at one, people proposed names for the collaborative sculpture; at another, they responded to the sculpture with small paintings, drawings, or mixed-media collage of their own; at another, they wrote down wishes that were later included in a two-dimensional collage.

Collaborate straight through to the closing of your closing. Involve students in the planning: "How would you like to celebrate our efforts? How can we share what we've done and let other people enjoy it too?" If you're inviting the press, have students write a fact sheet. Involve stakeholders in the orchestration. With a small group, hold a potluck. With a larger group, get a local restaurant to cater the event. Provide a comment book in which viewers can write their congratulations and responses to the art.

At many formal art openings, artists provide written statements describing what they had aimed to articulate with their work. For example, I've written about my interest in visual language and context; other artists have written about life as a construction and fabrication. Often philosophical, artist statements can also contain technical information about the making of the art. Ask students to brainstorm about what they'd like to say in a one-page artist statement. Encourage them to include an anecdote about the experience itself. If helpful, you can interview students and write an article to give to attendees.

Ask your students if they'd like to title the closing ceremony. While not necessary, an interesting title can engage, intrigue, and put a spin the project before viewers have seen a single piece of artwork. For my own exhibitions, I've tried to come up with catchy titles that represent the heart and soul of the works being exhibited: *32 Hours, Still Standing, Jacks Are Wild*. Suggest ideas, nominate finalists, weigh the pros and cons, and vote, giving students yet another opportunity to

debate and reflect on their art together. Keep in mind that the process of getting to the title is just as important as the title itself.

WHAT TO SAY AT THE CEREMONY

The closing ceremony is the "get it" moment, the moment when everything comes together for artists and viewers alike. Think of your role at the event as that of art educator par excellence. You need to both educate those who are seeing the art for first time *and* complete the process for participants so that they truly get what they've done.

First, let's consider the importance of publicly acknowledging the artists. It's easy to forget how important acknowledgment is. People want to be seen and heard and know that their efforts matter. The closing ceremony fulfills a promise of mattering. Aim to honor students' achievement, to remind them that they all have ownership in the final product, and to reinforce their self-esteem. A practical tip: Consciously try to look every student in the eye.

Now, the viewers. When art is abstract or out of the ordinary, it's easy for viewers to dismiss it out of hand; it may be foreign to their eye and to their idea of what art is. Your comments, therefore, can give viewers entrée into art that might otherwise befuddle them. Here are a few points you might want to emphasize:

- *The five organizing principles.* Master artist, frameworks, collaboration, the wider world, and contemporary art. Which ones were key to your process?

- *The power of cooperation.* Students signed on to collaborate and something amazing happened that couldn't have happened any other way.

- *The democratic process.* Discuss how the making of artwork together— from deciding on a framework to choosing colors—was in and of itself educational.

- *Curricular relevance.* In what ways has this artwork informed and enhanced your study of a particular subject?

- *Larger learning.* What modes of thinking, of creative problem-solving, were learned that aren't necessarily quantifiable on standardized tests?

Tell an engaging anecdote or two to animate and lend color to the artistic process in viewers' minds. For example, if I were talking about the high-school group in

the Bronx, I'd describe the impressive way students decided on the background design for their billboard. Kids presented strong rationales and were passionate about their positions, they listened to one another, they took a fair vote, and then each and every student got behind making the winning background the best it could be.

If I were talking about the Open Circle project, I'd highlight students' enthusiasm. Each student was charged with creating a pattern of dots that another student would then transform into a painting. The assignment became an exuberant, good-hearted contest: Who can make the most mind-blowing dot matrix as a starting place? As students showed each other their works in progress, they were so excited, you'd think they'd just scored the winning touchdown at a football game.

If I were talking about elementary students at the Charlestown school, I'd tell about a dramatic shift in group consciousness that happened near the project's end. As students collaged one another's paintings onto a freeform sculpture, several kids were distraught that their paintings weren't placed prominently front and center. I immediately halted all work and sat everyone down to discuss this. We talked. By the end of the conversation, students had bought in to the idea that there was value in providing a supporting role. They were bigger, better people for being willing to be part of the larger project and not be the top banana. When we went back to work, everything flipped. The most desired location on the sculpture was no longer the bull's-eye, dead center, but the walls of the crevice, which were basically invisible, and the underbelly you'd have to wiggle your way beneath the sculpture to see.

If you've gotten to this point, you've adopted many of the guiding principles and improvised lots of creative ideas of your own. Take time to pat yourself on the back. You and your students have pulled off something big, important, amazing even. My hat's off to you!

Good luck with your next project, however big or small. May you and your students create something wonderful. May you create magic.

Appendix
Playing the Ball: Techniques and Projects

When I coach tennis, I encourage students to play the ball—that is, to play the best game they can play given their own abilities. If they can accept their current skill level and not become frustrated with where they think they *should* be, they will enjoy the game far more and get better much faster. The same holds true for someone orchestrating a collaborative project. Work within your own—and your students'—abilities. Make sure the projects are ones you can comfortably run. Most artists succeed when they feel confident and in control of their process, and when their ideas are simple and straightforward.

Here is a listing of possible projects with step-by-step instructions to help you accomplish them.

Project 1: Collage

Take a number of two-dimensional images that have been created on paper or fabric and glue them onto a larger surface, like canvas.

1. Begin a collaborative collage project with the most basic materials, pencils and paper. You can also use colored pencils, colored markers, or acrylic paint. Acrylic paint stains clothes, so alert the students and parents ahead of time so they can bring in work shirts. Student-grade paint is cheap and archival.

Younger students do not generally have much control over details with paint, though they do love using it. Have them paint onto computer paper (nonacidic is best), or on small pieces of canvas or fabric.

2. Ask students to draw a self-portrait on a sheet of paper. Start with a simple oval, and add two circles for eyes, two circles for the nostrils, and a line for the mouth. Elaborate from there.

Collage of kindergarten-class work, Staten Island.

Mark Cooper, Self-portraits.

3. Next, ask them to draw a second self-portrait on a second sheet of paper and incorporate within the portrait a drawing of something they are studying, will study, or have studied in school.

4. Give the students ten minutes to work on the drawings and then ask them to pass them to the person to their right for completion. This step can be repeated a second and third time. Sharing the image-making promotes collaboration from the start.

5. Purchase a piece of canvas large enough to contain all of the students' images and enough Elmer's or soba glue to attach the drawings (a canvas drop cloth purchased at a hardware or paint store is archival and by far the cheapest).

6. Option: To get more for your money, dilute the glue by half with water.

7. Paint the glue onto the back of the drawings and onto the canvas and attach every student's contribution to the canvas in a grid or other pattern of your choosing. Option: Wear plastic gloves to avoid constant hand-washing.

8. Paint a layer of glue on top of the drawings to protect them.

9. This process can investigate any subject matter and can be done with a range of materials: photographs, fabric scraps, decorative paper, written fragments, and so on.

10. Option: Paint a stripe on the top and on the bottom of the canvas in acrylic paint, to serve as a frame.

11. Option: Attach lightweight found objects to the canvas. Use acrylic modeling paste as an adhesive and work with the canvas flat on a table. Wait an hour or until paste is hard before hanging the canvas on the wall.

12. Attach the canvas to the wall with finishing nails, staple it to a stretcher or to

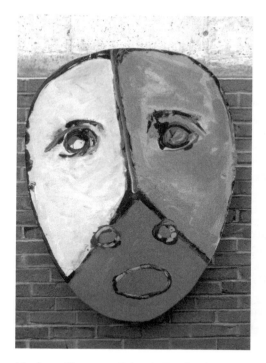
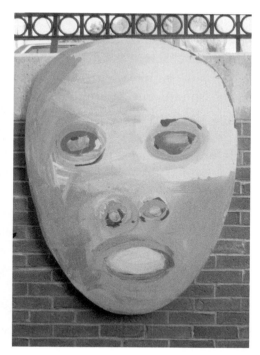

Masks at Haggerty School, Cambridge, Massachusetts.

any other rigid surface, or you can buy grommets at a hardware store, make holes in the canvas, and attach it to a wall using the grommets.

Project 2: Billboards

Billboards are traditional outdoor advertising spaces. Images are usually up for a month or two and then new images are glued directly on top of the old. After several layers, all images are scraped off and the process starts over.

1. Contact a local billboard company. They always have downtime and unsold billboard space and are typically willing to donate that space and installation to a good cause. Give them the flexibility in terms of space and display timing. Also give them the right to reject the billboard if it is too controversial.

2. Create a billboard that is a large-scale version of the collage process described in Project 1. Work with acrylic paint on larger pieces of paper, usually ten pages approximately 5 ft. 3 in. x 4 ft. 6 in. each. Billboard companies often supply the paper or will put you in contact with someone who will donate it. You can also work on smaller pieces of paper and then scan these into a computer. The company can enlarge the scans to make a full-size billboard.

3. Billboard companies take the responsibility for installation. You will need only to properly identify on the back of each page the order in which they should be placed.

4. Decide with your students on the collaborative process for each billboard. Everyone can have his or her own section, or the students can work together.

Project 3: Bronze Tiles
Bronze is very durable, indoors and outdoors. In general, artists work in clay, wax, or plaster, and then take a plaster mold of the original. Bronze is melted and then poured into the empty mold cavity. After the bronze cools, the plaster mold is broken away from the final object.

1. Dilute acrylic modeling paste to a consistency that will easily pass through a squirt bottle (like a ketchup bottle) while remaining thick enough to create a raised surface.

2. Cut out cardboard or wood squares for each student, teacher, staff member, and parent involved in the project. Ask each to create a self-portrait or other image using the squirt bottle as a drawing tool. The modeling paste squirts out much like cake frosting and after an hour or so it dries to a hard, durable consistency.

3. Take the tiles to a local industrial foundry that creates simple castings, such as nuts and bolts and fire poles for firehouses. They cast the bronze tiles more cheaply than a fine-arts foundry.

4. Install the tiles where and as you like. Use mortar or epoxy to secure tiles to an outdoor wall; indoors, use heavy-duty picture wire.

Project 4: Advertising and Display Spaces for Buses and Subways
Most subways and buses have advertising spaces inside above the seats and outside on the sides and rear of the vehicles.

1. Ask the transit authority for used posters from both the inside and outside spaces of subways and buses. Paint over the existing ads with primer, gesso, or a white acrylic paint, or use the backs of the displays.

2. Students paint or draw on the posters with acrylic paint or permanent nontoxic Dixon markers.

3. Variation: Backlit dioramas, the transparent images placed over lightboards in subways, airports, and bus and train terminals. Ask your local transit authority where you can acquire opaline, transparent film, or paper. You can usually get this from local graphic design material distributors.

4. Thin the acrylic paint with an acrylic gloss medium to a very watery consistency. Students paint on the transparent paper with this medium. For more opaque imagery, paint with less-diluted acrylic paint or use Dixon markers.

Project 5: Found and Recycled Sculptures

1. Students collect the same or various found objects: anything from shoes to bottle caps to old chairs.

2. Students transform objects in any variety of ways: painting them, assembling them in interesting arrays, nailing and screwing objects to surfaces, and so on.

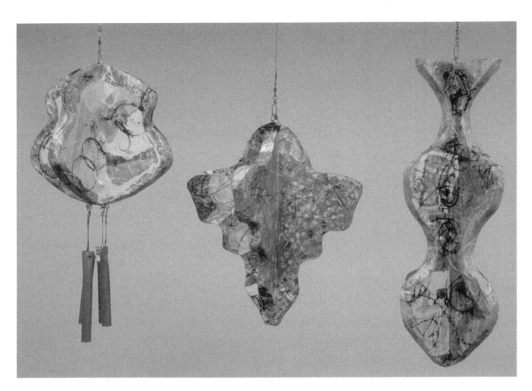

Small sculptures, wind chimes. First Night, Boston.

Project 6: Creating a Wooden Sculptural Form from Scratch

1. Decide with students on a three-dimensional form for a sculpture. Draw a full-scale paper or cardboard template.

2. Trace template onto pine or plywood. Cut wood with a simple jigsaw, attaching angle brackets to the individual pieces and screwing them together. (For an example of a wooden skeleton, see page 58.)

3. Staple canvas to the wood skeleton.

4. Prime the canvas with gesso or any acrylic paint.

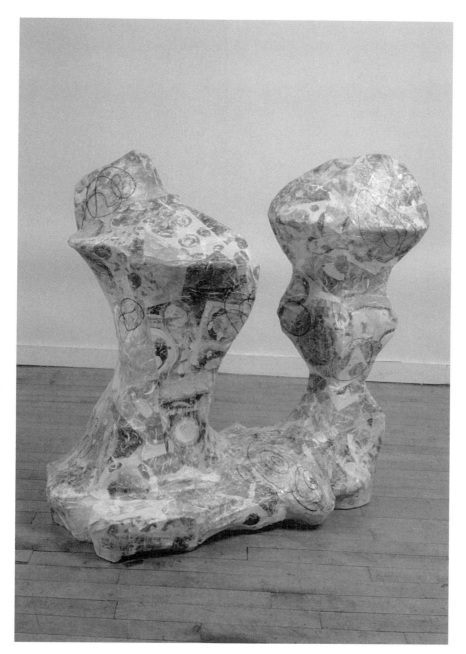

Sculpture, Open Circle project.

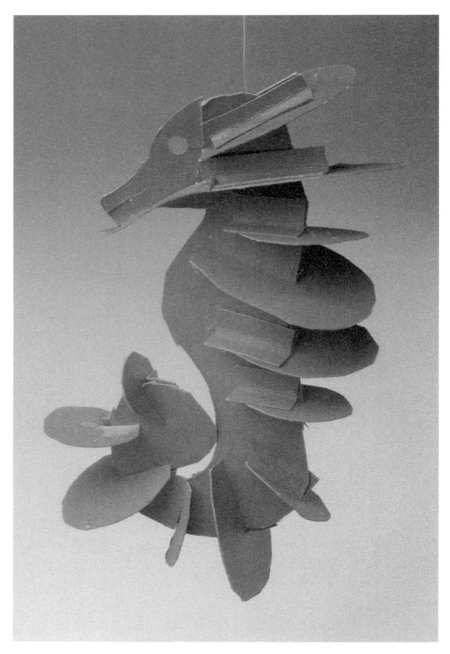

Cardboard template for large sculpture, made by students and voted on.

5. Students attach paintings, whether paper or fabric, to the sculpture. Brush Elmer's glue, soba glue, or acrylic polymer onto the backs of the paintings. Wear plastic gloves to attach these to the sculptural surface.

6. Option: If the sculpture will be an outdoor installation, fiberglass the form prior to the collage process for durability. Some fiberglass materials on the market are safer than others; speak with the supplier about application instructions.

7. After collaging onto the sculptural form, paint the surface with a UV-protective coating.

8. Option: Make a simpler three-dimensional form by nailing two-by-fours together or by wadding newspaper into a predetermined shape and using masking tape to bind it together. Coat with modeling paste and several layers of glue. Allow to harden, then collage. Alternatively, bend chicken wire into a form and apply a layer of plaster-soaked gauze, followed by a thicker layer of plaster.

Project 7: Outdoor Graphics
Transform your asphalt playground or basketball court using colorful self-adhesive plastic imagery; it peels away and can be applied much like linoleum on a kitchen floor.

1. With your students, decide on the imagery—anything from a photo of a cat or a building to a Xerox of a leaf to an original drawing.

2. Scan these images onto a disc.

3. Mail the original images or the disc to Sign Expo in New York City, or to any local graphics company capable of transferring your imagery onto outdoor, self-sticking, UV-durable material. Specify the sizes of the final images. Negotiate price. It typically will take several weeks to receive the final product.

4. Before installation, clean the outdoor asphalt playground surface using a simple broom or a high-powered hose.

5. Mix a two-part epoxy (a strong glue) and immediately apply to the back of the graphics.

6. Apply the graphics to the playground surface and allow a full day for the glue to set.